The Pillow Book

The Pillow Book

The Erotic Sentiment and the Paintings of
India, Nepal, China & Japan

Nik Douglas
& Penny Slinger

DESTINY BOOKS
New York

Destiny Books
377 Park Avenue South
New York, NY 10016

Library of Congress Cataloging in Publication Data

Douglas, Nik.
 The Pillow Book.

 Bibliography: p.
 1. painting, INDIC. 2. painting, Nepal. 3. painting, Chinese—Ming-Ch'ing dynasties, 1368-1912. 4. painting, Japanese—Meiji period, 1868-1912. 5. Erotic art.
I. Slinger, Penny. II. Title.
ND1003.D6 757'8'095 81-9760
ISBN 0-89281-012-2 AACR2

Cover and book design by Claude Martinot
Printed by Phoenix Color Corporation
Typography by Positive Type
Printed and bound in the United States of America

The authors would like to acknowledge the following, who have generously allowed the reproduction of art from their collections: The Kreitman Gallery (Beverly Hills), the Kumar Gallery (Paris and New York), Victor Lownes, David Salmon, and Sceptre Holdings Ltd.

Destiny Books is a division of Inner Traditions International, Ltd.

CONTENTS

Shedding my robes and removing my makeup,
I roll out the picture-scroll by the pillow's side;
Acting as an Initiatress into the Arts of Love,
We perfect the postures and taste those rare delights.
(Chang Heng's poem of a bride to her husband)

INTRODUCTION

In the ancient cultures of the Orient it was customary to present illustrated erotic manuals to a couple before the consummation of their marriage. India, Nepal, China, and Japan are the main countries where this custom long prevailed; only in recent times have these great Oriental cultures abandoned the tradition. The gradual Westernization of the East has brought about many changes in attitudes toward traditional values, especially with regard to the roles of sex and religion. In the new age of materialism the governments of most Eastern countries have restricted freedom of sexual expression, labeling explicit depictions of the sexual act as "pornography." As a result, illustrated love manuals have been banned, burned, or dismissed as mere curiosities of the past. Precious albums of erotica have consistently been damaged, broken up, and occasionally sold to inquisitive tourists and the occasional Western collector.

In 1968 I was a guest at a traditional Indian wedding in New Delhi. At a certain point in the ceremony the bride and groom were presented with an elaborately decorated "love book," which I was informed would serve to help the couple consummate their physical union. Though the traditional Hindu marriage ceremony had been followed, I was astonished to learn that despite the outer show, the pages of the volume were blank. The presentation of the erotic manual had only symbolic value. Upon further inquiry, I learned that modern Hindus had become too prudish to even consider looking at illustrated erotica, even though it is an integral part of their culture.

Oriental love manuals, or "pillow books," took several different forms. Usually a series of erotic events were depicted in drawings, prints, or paintings. These would then be placed in sequence and mounted on hand scrolls or fold-out albums or bound into small volumes. Subtle erotic verses or descriptions of erotic scenarios usually appeared between the illustrations, which would sometimes be embellished with quotations from famous classical treatises on the art of love, such as the *Kama Sutra* (in India) or *The Playful Variations of Master Tung* (in China and Japan). Occasionally, extracts from famous erotic novels or esoteric texts were added to the front, side, or back of the illustrations. Usually no expense was spared to create exquisite bindings or carrying boxes of precious materials such as silk, brocade, sandalwood, jade, ivory, or precious metals. The famous Chinese erotic novel *Chin-p'ing-mei* (The Golden Lotus), written toward the end of the Ming dynasty, gives the following description of an erotic scroll from the Imperial Palace collection: "It contains a series of pictures illustrating twenty-four love postures, each with its particular name. These pictures are exquisitely painted with a preponderance of the mineral colors blue and green, with outlines in purest gold. The borders are of the finest silk, and a brocade band is wrapped around the scroll when it is not in use. Finally, it is fastened with an ivory pin."

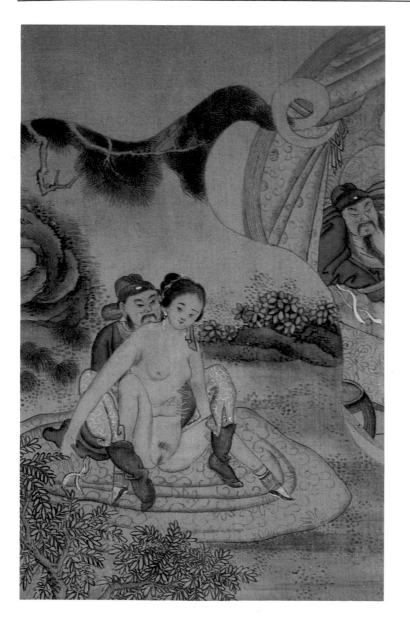

Pillow books served to break down barriers and initiate couples into the art and science of physical love. They also introduced newcomers to the aesthetics of fine art and literature. Furthermore, traditional Oriental religions taught that the sexual act could be viewed as the human counterpart to the cosmic creative process and as such has an inherent power to avert calamities. An early Chinese text of the Three Kingdoms and Six Dynasties period (A.D. 221–590) succinctly states: "The Bedroom Arts comprise the entire Supreme Way and can themselves suffice to help one achieve the goal of Immortality. These arts are said to enable a person to avert calamities and become freed from misdeeds, even to change bad luck into good fortune" (Ko Hung).

The original versions of classic Indian love treatises such as the *Kama Sutra* and the *Ananga Ranga* must once have been beautifully illustrated, not only with erotica but also with illuminated lettering and stimulating scenes from nature. Such is evident from close scrutiny of surviving texts as well as from references in classical Hindu literature. References to illustrated love postures as part of the ancient Hindu life style are many, as in the following quotation from the *Ananga Ranga*: "Decorate the beautiful walls of the love-chamber with pictures and other objects upon which the eyes may dwell with delight. Scatter some musical instruments and refreshments, rosewater, essences, fans, and books containing amorous songs and illustrations of love-postures."

From the twelfth century, India was dominated by outside influences. First the Muslim invaders exerted their influence on the culture, creating profound changes in the Indian attitude to sex; then the British rulers imposed their Victorian values. The Maharajas were able to maintain traditional

A Mongol nobleman is depicted dreaming of himself caressing a woman who sits with him upon her pink robe.

attitudes toward sex as a high art form, but only in the privacy of their palaces. Nevertheless, popular Indian erotic paintings survived, though separated from the love treatises that once inspired them.

Pillow books were often illustrated by great artists, usually working under noble patronage. Many important Oriental artists painted erotic themes at some time during their artistic evolution. This work of theirs was highly regarded for its sensitivity, technique, imagination, and subtle meanings. In India it was the Maharajas who extended patronage to the artists, providing materials, food, and shelter in exchange for their best works. Some of the most exquisite examples of Indian erotic paintings depict actual rulers engaged in love dalliance with their queen or concubines; an element of flattery was often added, emphasizing the virility of the Maharaja, the beauty of his consort, and the special features of his palace. A sense of bedroom aesthetics and the psychology of love would often be incorporated in the paintings.

There are many references to erotic art during the early periods of Chinese history, though no known illustrations survive. After the later part of the sixteenth century, fine erotic paintings on silk or paper were quite common among the nobility. However, during the Manchu conquest of 1644, most erotic albums were destroyed by order of the government. During the early eighteenth and nineteenth centuries erotic paintings reemerged in pillow-book format, though these were kept very private and rarely displayed openly.

At the time when erotic art was being suppressed in China, it emerged in its own right in Japan. Referred to as *Shunga,* meaning "spring pictures," Japanese erotica is related to, yet different from its Chinese inspiration. A particularly noticeable feature of Japanese erotica is the tendency to exaggerate the size of the genitals, just as in Chinese erotica the feet of women are generally portrayed as diminutive.

In the course of our research for *Sexual Secrets: The Alchemy of Ecstasy,* we studied a wide variety of erotic paintings from India, Nepal, China, and Japan. In the present volume we have brought together some of the finest examples from these cultures. We have arranged the illustrations in sequence, helpful to the understanding of both the sexual postures and the art. We have also included themes of pure fantasy that would undoubtedly defy practical application. We have also provided commentaries and quotations relevant to the serious appreciation of this art form.

The first part of our *Pillow Book* includes a number of exquisite Chinese paintings on silk, as well as fine Japanese *Shunga* prints and paintings. The second part features a wide range of erotic paintings from several different parts of India as well as the finest examples from a unique series of Nepalese paintings created for a king.

THE ART AND ITS SYMBOLISM

CHINA

All the original Chinese art reproduced in this book was created between the mid-eighteenth and the early twentieth centuries. However, the painting techniques, style, and iconography are all derived from much earlier periods, dating back to at least the twelfth century. This art was generally incorporated into books or scrolls, arranged in sequences designed to illustrate both sexological truths and the high aesthetics of physical love as an art form. Most of these paintings were created with finely ground mineral pigments mixed with an adhesive medium and applied to a natural-colored silk ground, mounted on card, paper, or brocade; the few examples of watercolors were painted on rice paper. All these paintings were the result of some form of patronage.

The artists who painted these pictures were truly masters of the erotic sentiment. They combined a delicate palette with

spontaneity of line, understanding of space, and attention to detail, in such a way that the overall effect is both moving and deeply meaningful. Specific sexual postures, facial expressions, color combinations, and the inclusion of precise symbolic elements—such as dragon or phoenix motifs, open lotuses, full peonies, bursting blossoms, red candles or columns, stags, and cranes—were carefully blended together according to Taoist traditions reaching back to at least the later Han dynasty (A.D. 25–220). As a result, these paintings have a deeply symbolic meaning.

Taoism teaches that man and woman are microcosms of the universe and that during sexual union they serve a cosmic function. An ancient Taoist aphorism declares: "The union of man and woman is like the mating of Heaven and Earth." In any consideration of Chinese erotic art, this teaching should be borne in mind, since this is the truth which the artists were endeavoring to express. Taoist teachers evolved sexual-yogic techniques designed to harness the creative energies of both Heaven and Earth and developed a subtle esoteric symbolism to express the interrelationship between the two. Art played an important role in communicating the process, helping to educate while at the same time preserving the esoteric content; only those who had the key could truly unlock the meaning of the complex symbolism and find the secrets. Though this was largely an oral tradition, brief verses or quotations from Taoist sexological treatises would sometimes embellish erotic Chinese paintings and provide clues to the esoteric content; often these inscriptions would be quite enigmatic, almost in the form of a riddle and requiring considerable knowledge of metaphysical literature before the connections could be fully understood.

Many Taoist teachers compiled information on love postures, breathing techniques, visualizations, and cosmic relationships in the belief that this science was the key to the art of harmony in life. Love postures were poetically named after particular creatures or concepts, and when artists began to create illustrated erotic manuals, this information was generally included within the subtle symbolism of color, form, and content. It is a remarkable fact that, no matter what period of Chinese erotic art is being considered, the iconographic and symbolic content is consistent and can be interpreted in relation to the earliest Taoist sexological writings, some of which are attributed to women.

A peculiar feature of Chinese erotic art since the Sung period (A.D. 908–1279) is that the feet of women are generally shown as diminutive and covered by shoes or leggings. Since very early times small feet have always been a sign of womanly beauty in Chinese culture, but it was not until the twelfth century that foot binding became fashionable; the practice lasted until the early twentieth century. Though the precise origin of this curious custom is unknown, it appears that foot binding restricted a woman's freedom of movement and at the same time altered her gait, much like the effect of modern-day high heels. Some Chinese writers have suggested that restricted movements became symbolic of womanly modesty and allure, whereas others have declared that the special gait resulting from foot binding caused a particularly desirable development of the female sexual muscles and reflexes, resulting in increased sensuality and sensitivity. Whatever the truth, in Chinese art, cultured women were invariably depicted with tiny bound feet, often covered by exquisite leggings; the touching of a woman's feet was considered very suggestive, and foot fetishism is a common occurrence in Chinese erotic literature.

An important aspect of Chinese erotic art is that it reflects a society whose aristocracy was largely polygamous. Accordingly, quite a high proportion of *Pillow Book* illustrations depict one man making love to more than one woman, and on occasions two women are shown making love to one another. Polygamous sexual scenarios are referred to as Secret Dalliance and are generally associated with Taoist techniques for potentizing the male (*Yang*) principle and harmonizing the

female (*Yin*) principles; in this context the secret Taoist techniques for retaining the semen are an essential part of the male role. Precise love postures were evolved so that sexual energies could be exchanged and circulated correctly during the practice of Secret Dalliance.

JAPAN

We have reproduced a number of Japanese erotic illustrations throughout this book, all of which date from the mid-eighteenth to late nineteenth century; some examples are paintings on silk, while others are colored woodblock prints on rice paper. Though the overall effect of Japanese erotica is somewhat different from that of its Chinese counterpart, both derive the iconography from a common source in the sexological texts of the early Taoist period.

Japanese erotic illustrations tend to be much more dynamic and emotional than the Chinese equivalent, even when identical postures are portrayed. The sexual organs are almost always depicted greatly magnified in size, even grotesquely so. Bound or covered feet are very rarely shown in Japanese erotic art, wherein it is quite common to portray a woman's toes in precise detail as they curl in the ecstasy of fulfillment. Erotic abandon is very much a part of Japanese *Shunga*, whereas Chinese erotica is reserved and calculated, illustrating passion under control.

Greatly enlarged sexual organs are a feature of very early Japanese art and generally occur as talismans or fertility symbols. The fact that this feature has survived in *Shunga* paintings and prints is an indication of the lasting influence of the pagan Shinto religion, with its origin in primitive phallicism. Though Buddhism extended its influence into Japan from the sixth century onward, the Japanese attitude to sex remained essentialy pagan, with emphasis mainly on physical release rather than spiritual union. As a result, Japanese erotic art developed a freedom of expression rarely

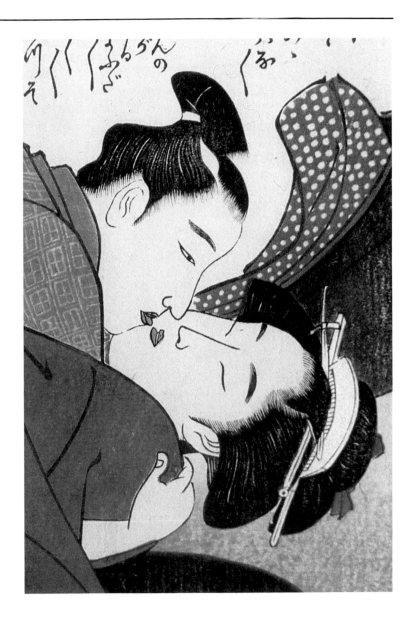

A noble couple are shown kissing as they prepare to make love.

found in Chinese erotica. By the late seventeenth and early eighteenth century *Shunga* ''spring pictures'' had developed as a popular medium for art publication. Many well-known artists began to work out posture sequences, drawing inspiration both from the ancient Taoist love manuals and from the circles in which they moved, such as the Kabuki theater, Geisha houses, and brothels.

Japanese *Shunga* art covers a wide range of sexual scenarios.

Though most depict heterosexual couples in dalliance or making love, and an occasional group scene with a man and two or more women, it is not uncommon to find explicit portrayals of both male and female homosexual activities as well as rape scenes, anal sex (with men and women), and sadomasochism. This feature of Japanese *Shunga* is unique to Oriental erotica as a whole and is probably due to a combination of the strict sexual repression during the early Buddhist period and the later

A Hindu Maharaja kneels making love with his consort in the classical Indrani posture.

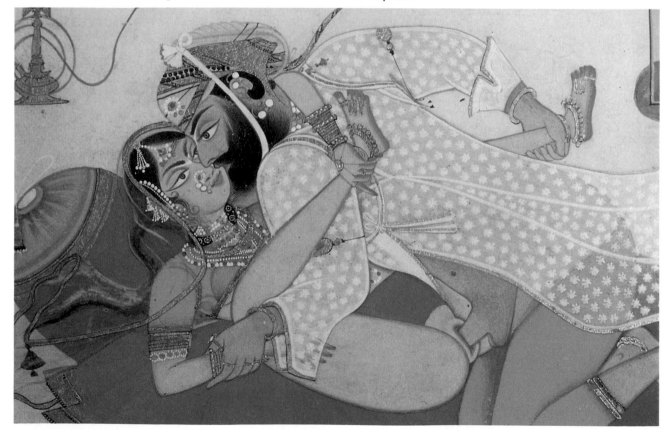

popularization of heroic aggression of the Samurai warriors, many of whom took young men as lovers. Depictions of sexual aggression and "taboo" topics are not, however, part of the pillow-book tradition, and for this reason we have not included them in our collection.

INDIA

All the original Indian art reproduced through this book was created between the early eighteenth century and the beginning of the twentieth century. A wide range of different artistic styles is represented, including examples from the Deccan, Bengal, Lucknow, Basohli, and the Rajasthan Hills as well as from the Sirohi, Bundi, and Jodhpur regions. Most of these paintings were created with finely ground mineral pigments, using a gouache technique applied to a sized and highly polished paper ground; the few watercolors from Bengal are remarkable for their technique of fluid brushwork combined with an imaginative use of line and shade. The overall effect of these fine paintings is to uplift the human spirit and bring it into harmony with nature through the power of sensitive and meaningful eroticism.

Indian erotic paintings have an ancient tradition in the Hindu art of love, serving to delight the eye and stimulate the senses, as well as conveying important cultural, sexological, iconographic, and metaphysical information. Sequences of love postures are the principal theme, though the personages, facial expressions, color combinations, and symbolic content are all very significant and can be precisely interpreted. Inasmuch as the Hindu aristocracy was largely polygamous, some of these paintings depict one man making love to two or more women simultaneously, usually in a ritual context. The several examples of multiple lovemaking in complex horse shapes are purely talismanic and were created with the purpose of attracting good fortune through the magical power of sex.

In Indian culture, portrayals of the sexual act have always been endowed with magical properties. Sculptures of loving couples commonly adorn Hindu temples and are believed to serve a protective and empowering purpose, pleasing both gods and humans alike. Hinduism developed during the Vedic period (c. 1200–800 B.C.), becoming an amalgam of cults, most of which centered on sexually oriented rites such as the great *Soma* sacrifice, in which intoxicants were consumed while songs of ecstasy were sung; during this rite a noblewoman would ritually make love with a priest, who symbolized the Divine Being.

By the second century A.D., Indian sexology had evolved to such an extent that authoritative source texts such as the *Kama Sutra* were created. These texts prepared the way for the introduction of Tantric practices in which the senses were explored and utilized as aids to achieving the great goal of Liberation.

Tantra teaches that physical love can be an effective and joyful way of achieving ecstasy, but also warns of the dangers of treating sex casually. Like Taoism, Tantra emphasizes the interrelationship of microcosm and macrocosm, the "inner" and "outer," and developed an evolved sexual-yogic technology which focused on love postures, breath control, visualization techniques, and an understanding of the cosmic relationships linking mind and body, Heaven and Earth, man and woman. The influence of Tantric philosophy extended throughout Indian culture and can be clearly seen in most fine examples of Hindu erotic art as well as in present-day Hindu ritual. Tantric love postures, yogic gestures, symbolic color combinations, and the presence of ritual items all commonly occur in Indian erotic paintings even at a late period and are particularly frequent in examples created under royal patronage. Obviously such paintings were to be understood on several different levels, depending on the degree of familiarity with the esoteric content.

We have chosen examples of Indian erotica that are

aesthetically pleasing and also convey important Tantric truths. Familiarity with the material is the most effective way of understanding subtle symbolism, and this wide range of erotica is no exception. Seemingly minor details such as hand gestures, postures, specific ornaments, ritual items, times of the day or night, and color combinations have a deep significance when understood in a Tantric context. Wherever possible, we have indicated these connections in our captions, and we have arranged the material so that a natural progression is maintained both with regard to the postures and the symbolic content. Here is an ancient art form that is truly a celebration of the creative sentiment and the urge to ecstasy.

NEPAL

Nepalese erotic art owes most of its inspiration to the various schools of Indian painting and sculpture, though Tibetan and Chinese influences occur on occasion. Both Taoist and Tantric teachings reached Nepal in early times and had a strong effect on the culture. As a result, most Nepalese art is highly symbolic, can be interpreted on an esoteric level, and commonly has an erotic content. Hindus and Buddhists have coexisted peacefully in Nepal for many centuries, each philosophy adding something to the other. Nepalese artists came from both communities and were always much in demand, not only in Nepal itself, but also in neighboring countries such as Tibet and China.

We have fortunately been able to reproduce the best examples from a unique series of large-format ''miniature'' paintings created in Kathmandu for an important Nepalese king around 1830. One example in particular represents this king in union with his queen and acting out the role of the

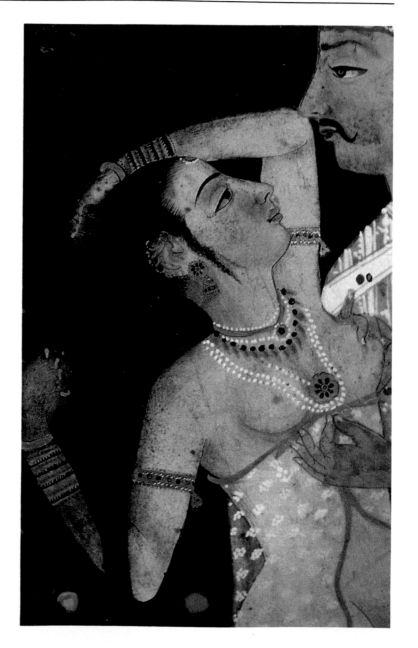

A nobleman caresses the left breast of his partner as she holds back her hair.

Hindu deity of Preservation, Lord Vishnu, seated on an elaborate throne. Painted with fine mineral pigments using a gouache technique on a sized and polished heavy paper ground, these extraordinarily powerful erotic illustrations depict various historical personages in sexual union. Inscriptions identify each couple, most of whom are royalty, and include pertinent information; Hindu rulers, Mongolian warlords, and shahs of Persia are all part of this noble assemblage.

All these Nepalese paintings are in a common style derived directly from the famous Sirohi school of painting, which evolved in Rajasthan, India. It is probable that the artist who created them had either trained with a Sirohi master painter or spent considerable time studying the intricacies of this style, perhaps through having access to fine Sirohi paintings in the collection of the Nepalese ruler whose patronage he enjoyed. Each of these paintings is unusual inasmuch as the scale is large, yet the detail is exquisite. The overall impression created by these fine works is both impressionistic and ecstatic, yet the formality of many of the settings adds a regal quality.

The Tantric content of these rare Nepalese paintings is immediately obvious. The postures and mystic gestures can be traced directly to esoteric source texts, and many details attest to a deep involvement with Tantric ritual. The idea that rulers of nations could influence the destiny of a country by virtue of their proficiency in love techniques is very much a part of pagan culture, and there can be no doubt that these portrayals of important rulers making love with their queens were created in the belief that they might serve such a function.

Nik Douglas

CHINA
AND JAPAN

Feasting and sporting with the Living Goddess
of Fortune,
Point out the Pictures of Love;
Spending the nights in her precious company,
Observe the sequence of love-images
And enjoy their special qualities.
(Poem of the Han dynasty)

This opening page from a pillow book shows a Chinese noble couple looking at an ancient erotic scroll painting while tenderly caressing each other. Two bound volumes of erotica rest on one side of the table. The palette is of cool mineral colors.

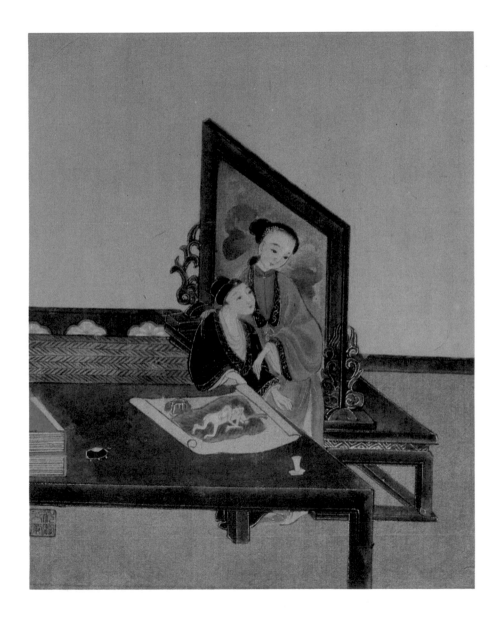

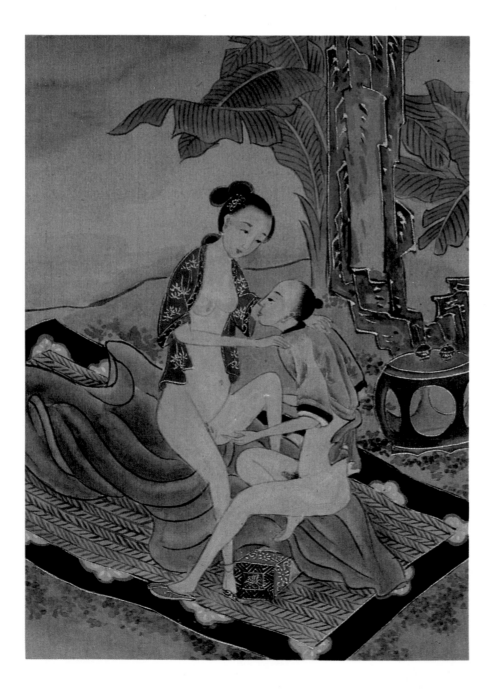

This fine Chinese album painting shows a couple engaged in foreplay upon a mat within a private garden. The man gazes longingly at his partner's breasts while reaching to caress her "Jade Gateway." Two teacups are placed close by, for refreshment. The banana grove beyond suggests the abundance of their love.

Here an interior scene shows a Chinese couple looking lovingly at each other while engaged in foreplay upon an ornate mat. The woman caresses her partner's "Jade Stalk," while he clasps her tiny foot. Behind them a pink lotus bursts open, suggesting sensual awak - ening. The subtle hues harmonize with the delicate skin tones, creating a mood of anticipation.

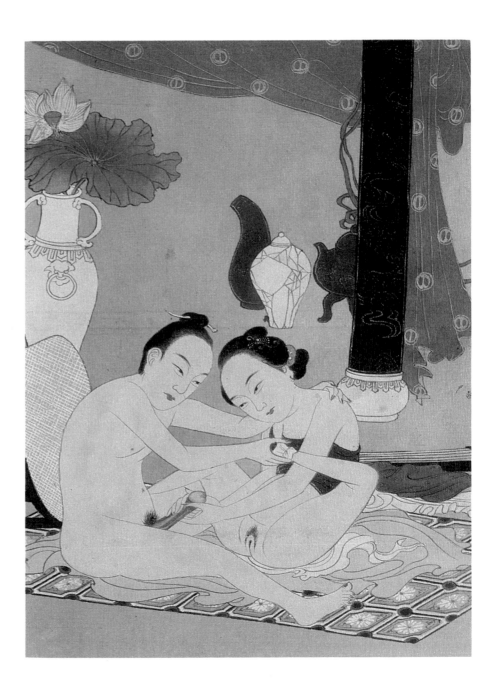

In a detail from a Chinese watercolor a man is shown kissing his partner's right breast while she wraps her legs around his neck and holds a fan in her left hand. Taoism teaches that a subtle vitalizing essence known as White Snow, Essence of Coral, or Immortality Peach Juice is produced from the breasts of a woman when she is sexually excited. The delicate colors of this composition convey a mood of tenderness.

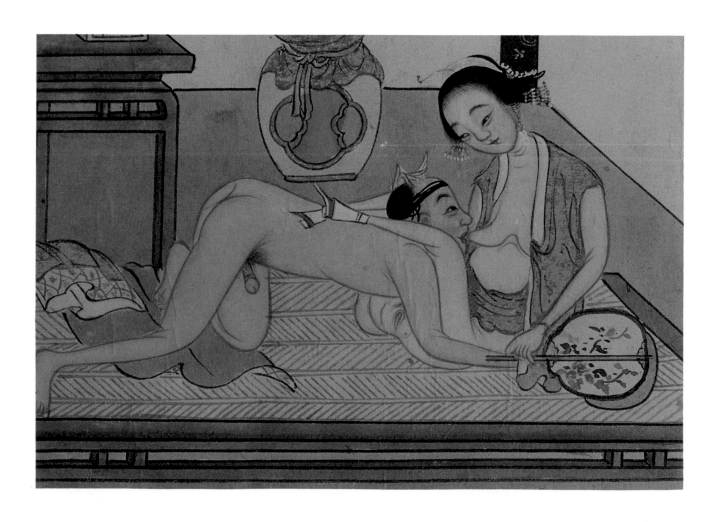

A Chinese couple are shown engaged in foreplay upon a mat. The woman firmly clasps her partner's "Ambassador" as she gazes at his face; he in turn gently opens the lips of her "Honey Pot."

In this detail from a larger composition the mineral green and blue highlights contrast with the larger expanse of neutral tones as the crimson and gold details take on a jewellike quality.

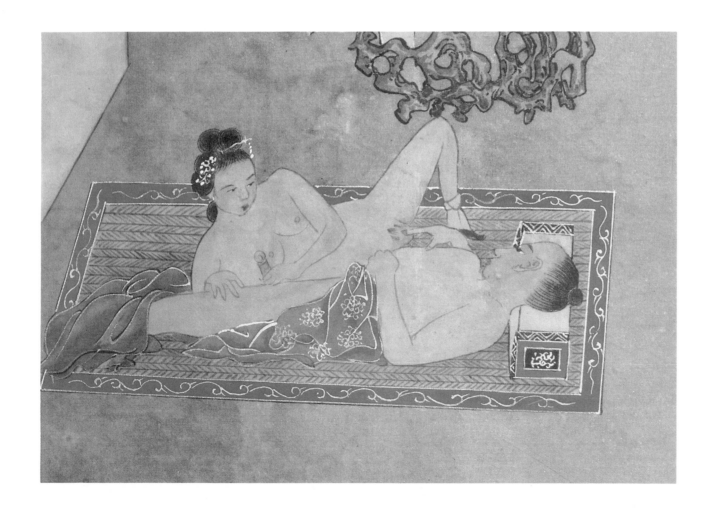

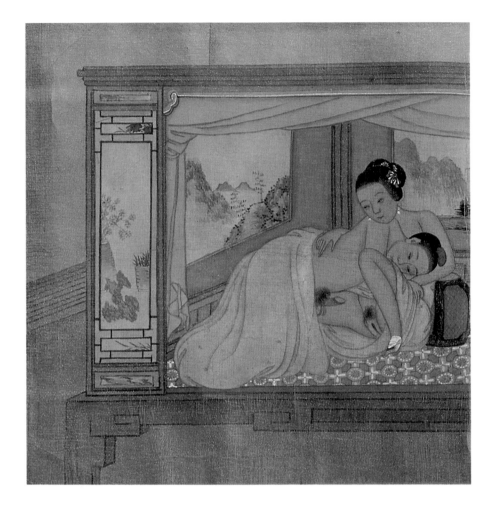

A Chinese couple are shown preparing to make love on an ornate bed which is almost a room unto itself. A mood of tenderness and love is expressed as the man leans over his partner's body, as if in worship, before penetrating her "Love Grotto." Exquisite landscapes embellish the bed, adding an air of naturalism.

Every time a man wishes to make love, there is a certain order of things to be followed. In the first place the man should harmonize his mood with that of the woman. Only then will his Jade Stalk rise.

(Su-nu-ching)

This *Shunga painting shows a Japanese couple about to make love upon a futon mattress. His "Weapon of Love" ready for "battle," the man turns to look over his shoulder, perhaps at a sudden intruder who has disturbed their intimacy.*

Their two hearts beat as one,
They pressed together fragrant shoulders
And touched each other's cheeks.
He grasped that perfumed breast,
Smooth as the softest down,
And found it perfect.

(Chin P'ing Mei)

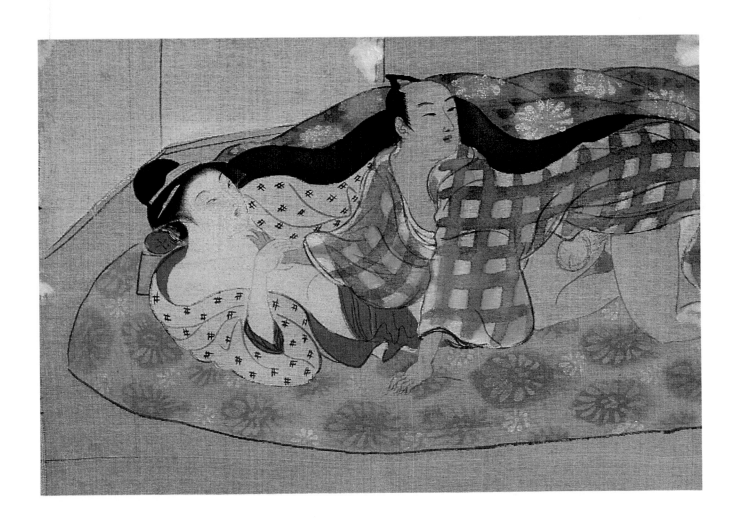

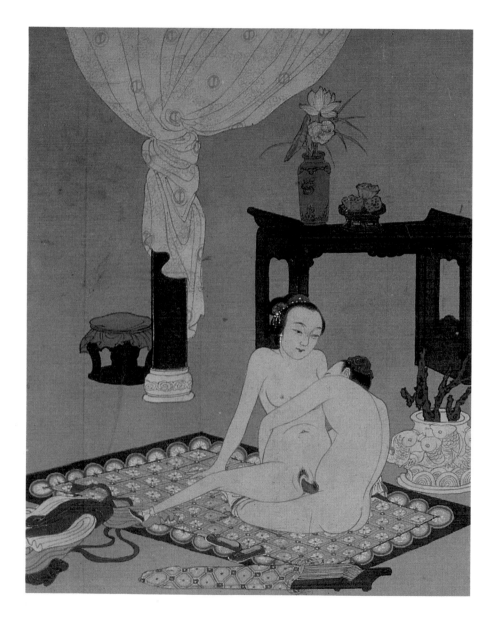

The "Positive Peak" has entered the "Pleasure Grotto." A Chinese couple sit in union upon an ornate mat while a pink lotus bursts open on a table behind them. As they perform the Taoist love posture known as Shouting Monkey Embracing a Tree, the man sucks his lover's left breast while she gazes at him serenely. To one side a fish-motif pot contains a bonzai miniature tree, the pot symbolic of sexual energy and the tree of longevity.

This **Shunga** *print shows a Japanese couple in a version of the classical Shouting Monkey posture. The woman raises up a cup of wine to her lover's lips while seated in union upon him;* she personifies the Geisha spirit of service and active eroticism. The lively mixture of warm and cool colors enhances the play between active and passive roles.

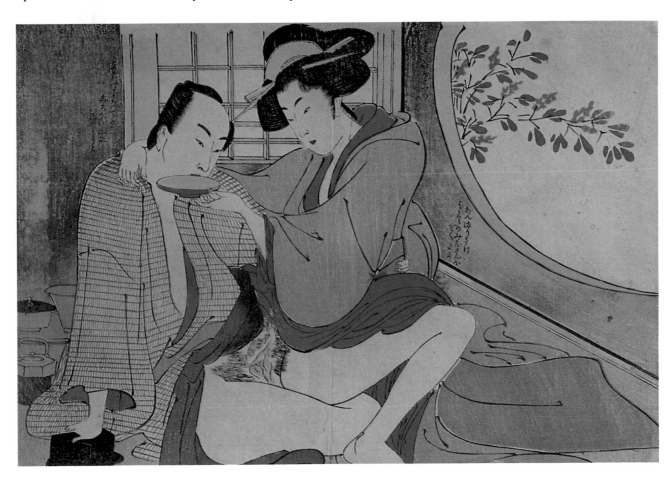

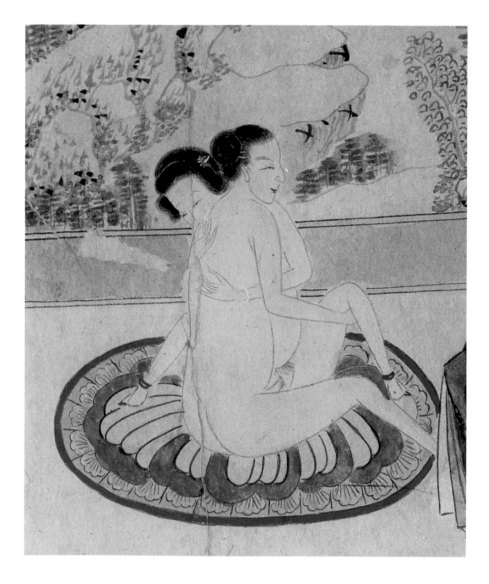

Here a Chinese couple are shown seated in union upon a brightly colored circular mat within the confines of a house. They make love in the Taoist All-Encompassing posture, devised to prolong ecstasy and enhance the mutual absorption of love essences; behind them a large painted screen displays scenes of nature.

Suddenly he lunged and reached the innermost Citadel; for within the Gate of Womanhood there is a Citadel, like the heart of a flower, which if touched by the Conqueror, is infused with wonderful pleasure. (Chin P'ing Mei)

A Japanese couple are seated in close union in the classical posture known as Cranes with Joined Necks. The pale translucent skin of the woman's back forms the central focus of this composition of gracefully flowing lines and natural earth colors.

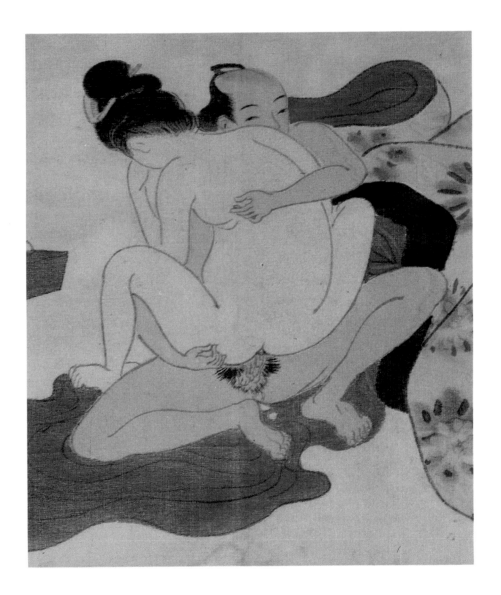

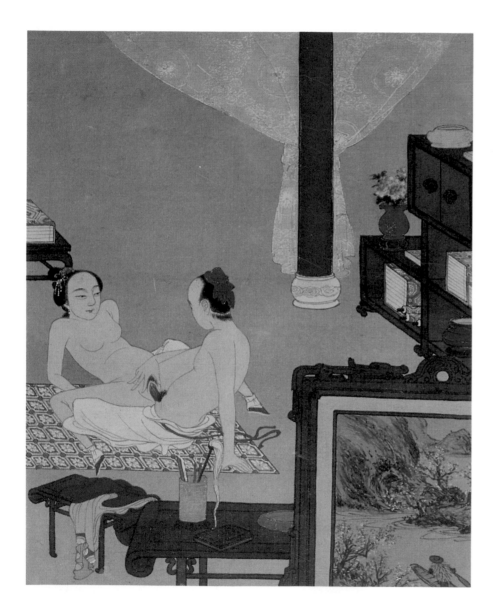

A Chinese couple make love in seated union upon a mat within a room. The diaphanous drapes and fine furniture and fittings seem to reflect the pink hue of the lovers' naked skin. As his partner leans back, the man presses his right hand around her "Golden Furrow" to aid control over ejaculation; this is a variation of the classical Taoist love posture known as Fluttering Phoenix. The blossoms on the screeen and in a vase on the table suggest renewal.

The woman is shown seated with her back to her partner in the Taoist love posture known as *Mountain Goat Facing a Tree.* The blues and purples of this **Shunga** *print from Japan convey a mood of mystic eroticism, heightened by the wild abandon of the couple.*

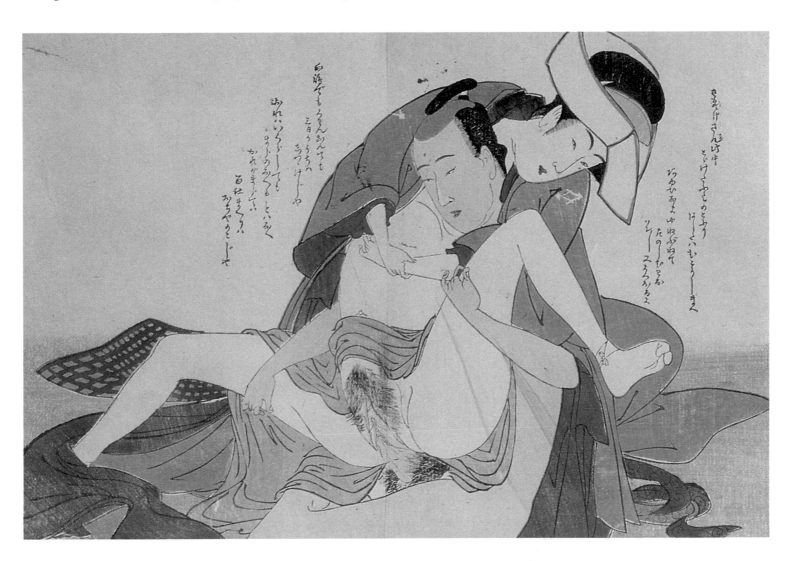

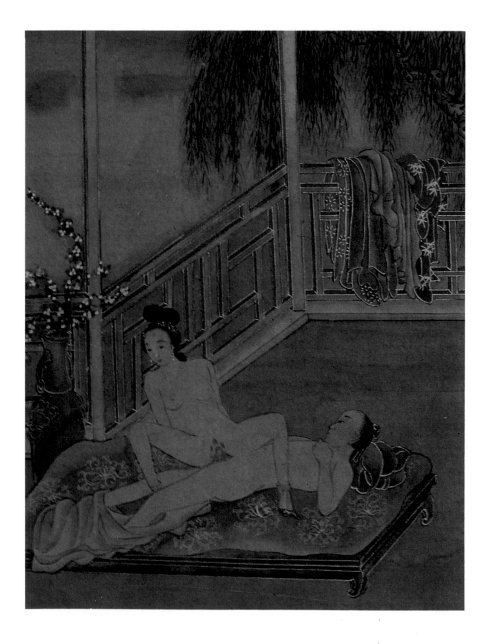

A Chinese couple are shown in union upon a bed placed on a veranda. Their discarded garments hang over a railing, behind which a willow tree, symbolic of constancy, can be seen. The couple are performing a secret Taoist therapeutic love posture in which the woman is dominant while the man retains. The vase of blossoms by their side suggests renewal.

33

This fine Japanese print depicts a
couple in union in the Pawing Horse
posture, the man artfully raising his
partner's leg while she leans upon a
pillow. Love-cloths are scattered in the
foreground.

Spring has come and the flowers are brilliant with color;
Responding to the rhythms of love, your supple body moves.
Opening, opening is that most Precious Bud;
My drops of dew help your Peony bloom.

(Chang Sheng)

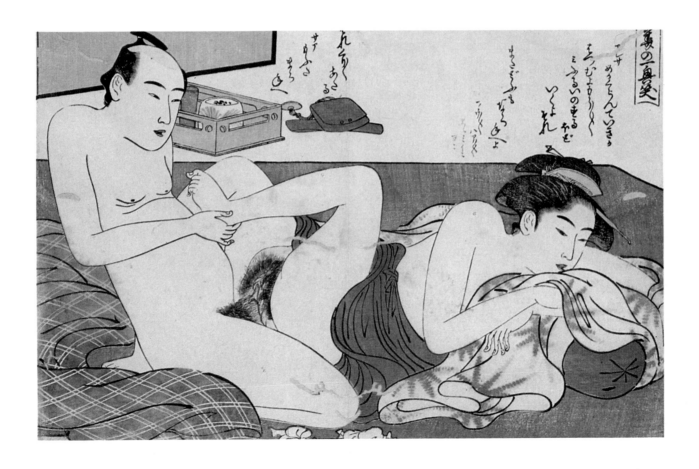

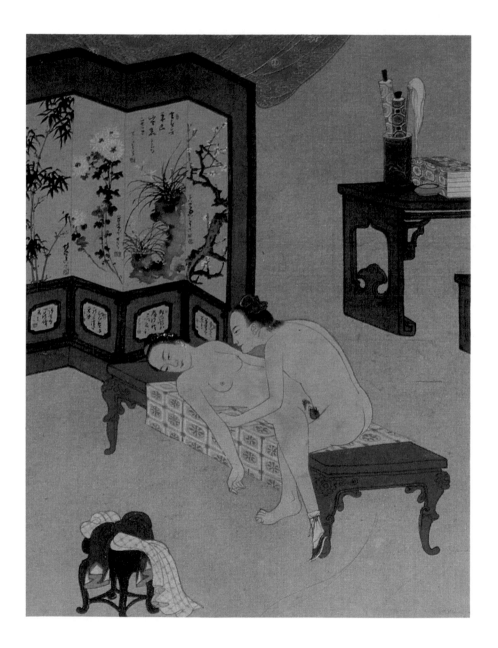

A Chinese couple make love upon a red lacquer bed behind an exquisite folding screen decorated with studies from nature. The woman leans back suggestively in the posture known as Pair of Swallows, turning her head to one side. A feeling of intensity is suggested by the red colors contrasting against the pale skin and yellow silk background.

Passion develops as a Chinese couple make love in the Fluttering Phoenix posture upon a couch. A nearby table holds two pillow books and a burning red candle, suggestive of the fires of passion.

On a screen behind the couple are painted a pair of cranes, symbolizing fidelity, and an antlered deer, the glyph of virility. The use of gold to outline the forms of the composition adds a spiritual quality.

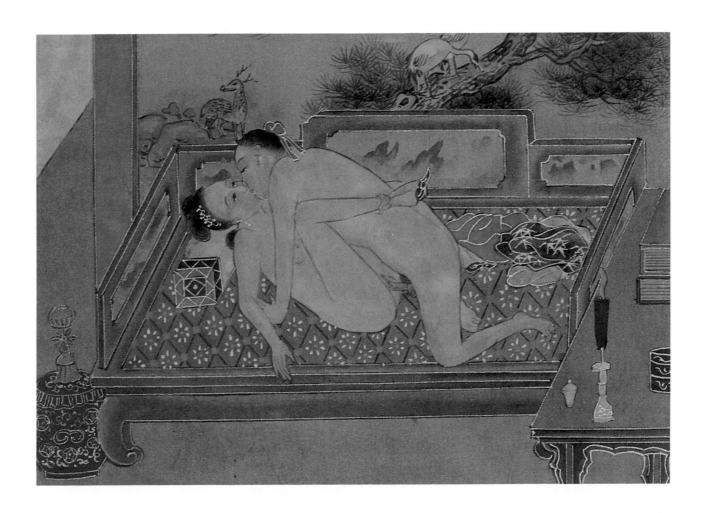

This Shunga *painting shows a Japanese couple performing the Turning Dragon love posture. Love-juices are shown flowing outward from the "Mysterious Cavern"* of the woman, who clasps her partner . *The darker skin tone of the man emphasizes the alabaster whiteness of the woman's body as her toes curl in ecstasy.*

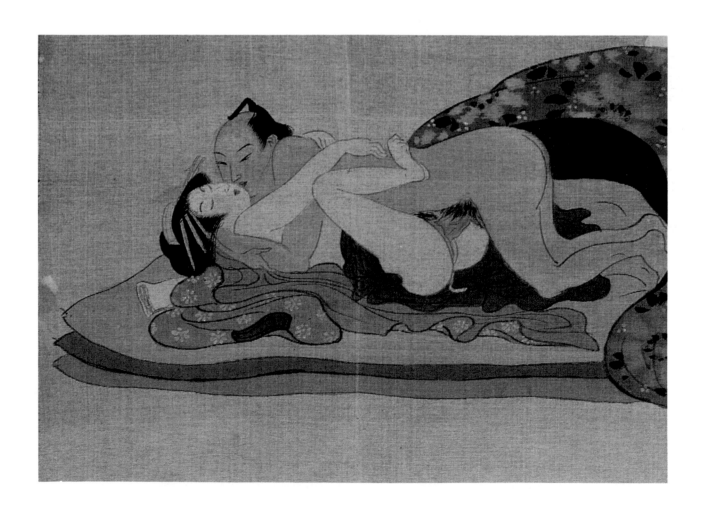

This fine Shunga print depicts a Japanese couple performing a variation of the Turning Dragon posture upon the floor in a moment of pure spontaneity. Love-juices flow copiously from the woman's "Pleasure Portal." The purple and red colors dominant in this composition aid the vivid expression of dynamic eroticism.

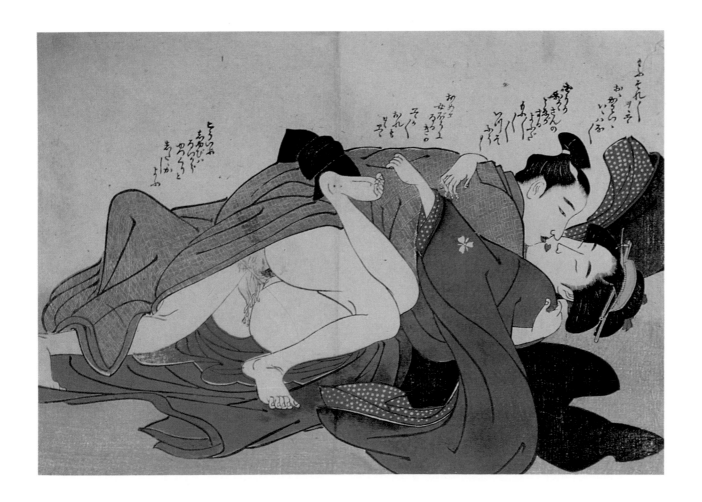

A Chinese couple perform the "Mysteries of the Clouds and Rain" upon a beautiful bed ornamented with fine silks and naturalistic paintings. The woman ardently clasps her lover to her body as he spreads her thighs wide and moves his "Yang Pagoda" in and out of her "Secret Cavern."

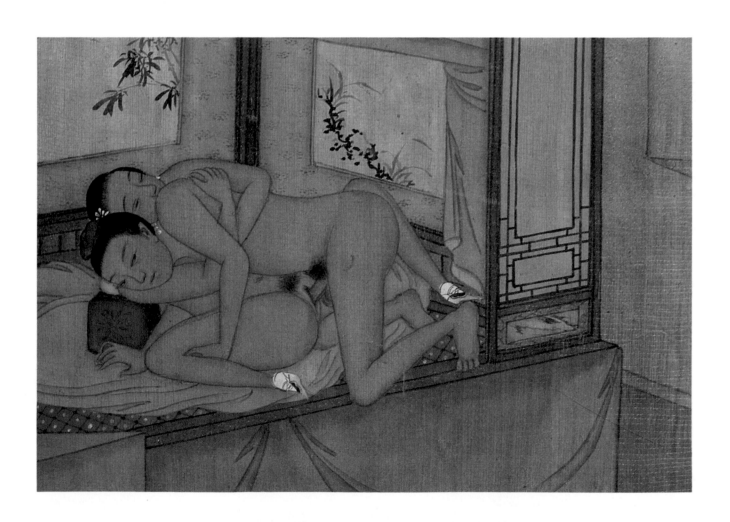

This Shunga painting depicts a partly clothed Japanese couple making love upon the floor in the Taoist posture known as Pair of Swallows. The woman lies back, her head resting on a hard pillow and her eyes closed; the man leans over and reaches for her "Valley of Joy." A mood of time-lessness is created by the combination of color and line.

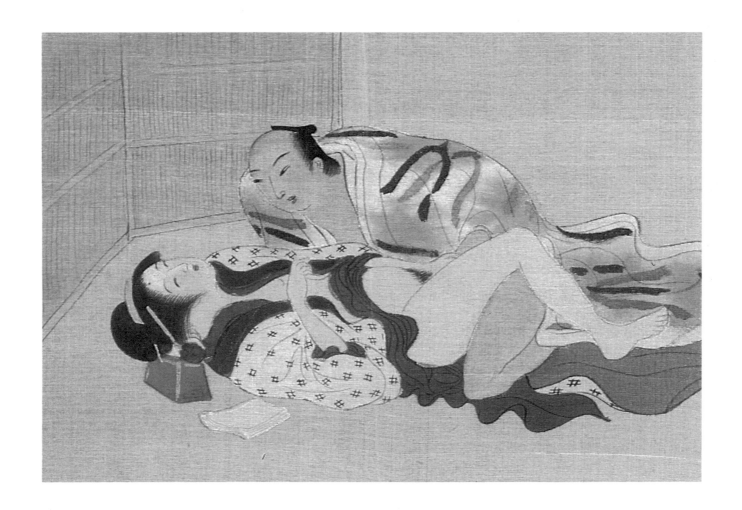

In this extraordinarily powerful Shunga print a Japanese couple are shown making love in absolute abandon. In their passion they have fallen from the bed. The woman's hair is disheveled and her thighs are wide apart as she raises up her "Pleasure House" to accommodate the busy thrusts of her partner's "Ambassador." Love-cloths lie scattered on the floor, suggesting climaxes already past.

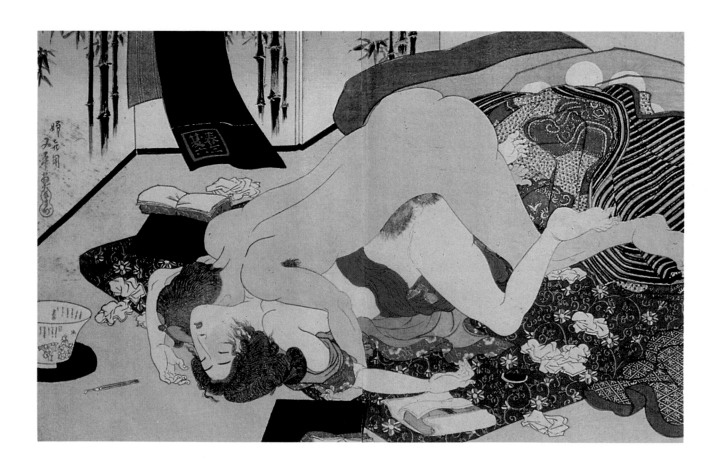

A Chinese couple recline on a bed, gazing into each other's eyes; it seems they are moving from one position to another. As the man carefully inserts his "Jade Stalk" into the "Cinnabar Crevice," the couple move into the Taoist posture known as Mandarin Ducks. The pale lilac drapes cling suggestively to a crimson column as a kettle rests on a bed of embers, ready for refreshment once the "Battle of Love" has taken its course.

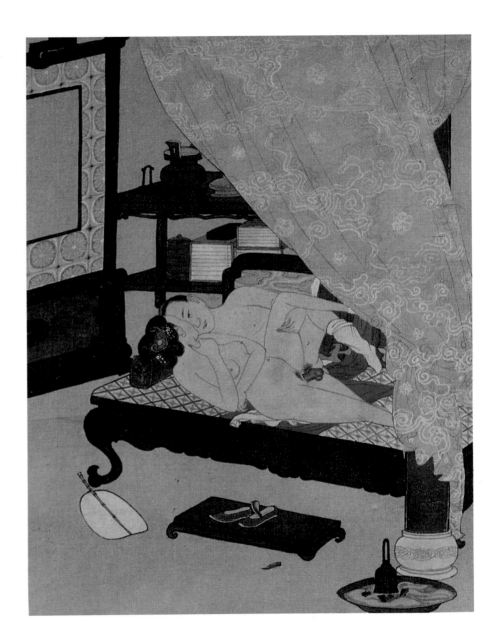

In this detail from a Chinese painting, a couple make love upon a carved bed. As the woman lies back and holds her left hand in a mystic gesture used for controlling and channeling sexual energy, the man leans over her, inserts his "Jade Stalk," and moves into the classic Taoist posture known as Pawing Horse.

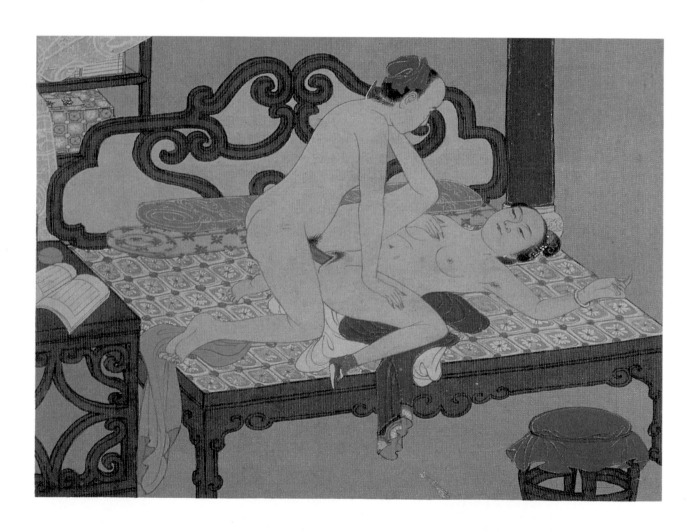

In a detail from a Chinese watercolor a couple are shown making love outdoors in the Taoist posture known as Overlapping Fish Scales. The lovers rest their naked bodies on banana leaves, their discarded clothes seeming like pools of color before them. The subtle palette of this composition accents the sensitivity expressed on the couple's faces.

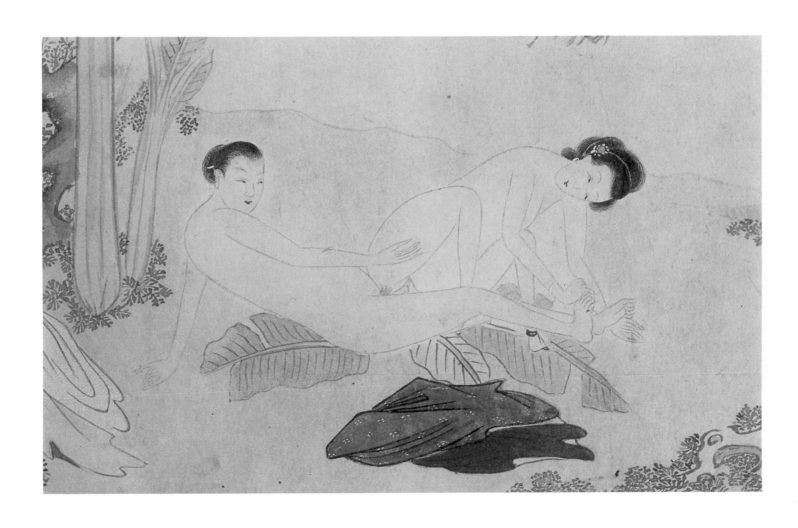

A Chinese couple making love upon a mat. The bowl of sprouting bulbs in the foreground symbolizes the upward flow of sexual energy produced by the correct practice of this therapeutic love posture.

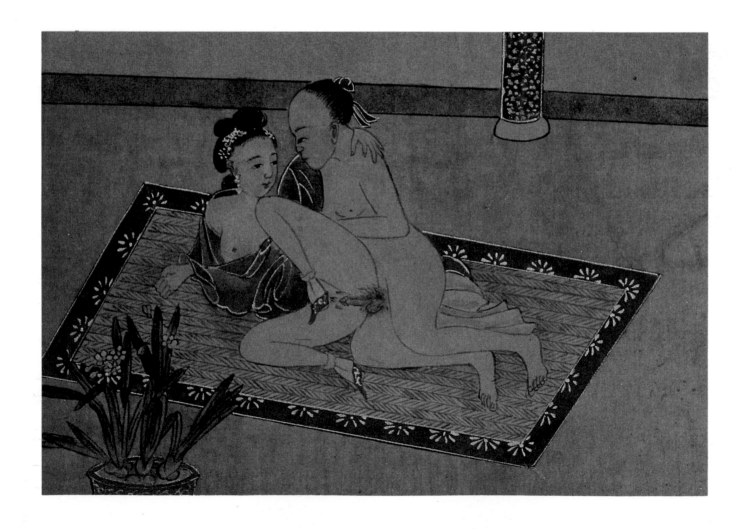

Here a Chinese couple, united in love upon an unusual ornate bamboo bed embellished with gold floral highlights, perform the Taoist love posture known as Mandarin Ducks.

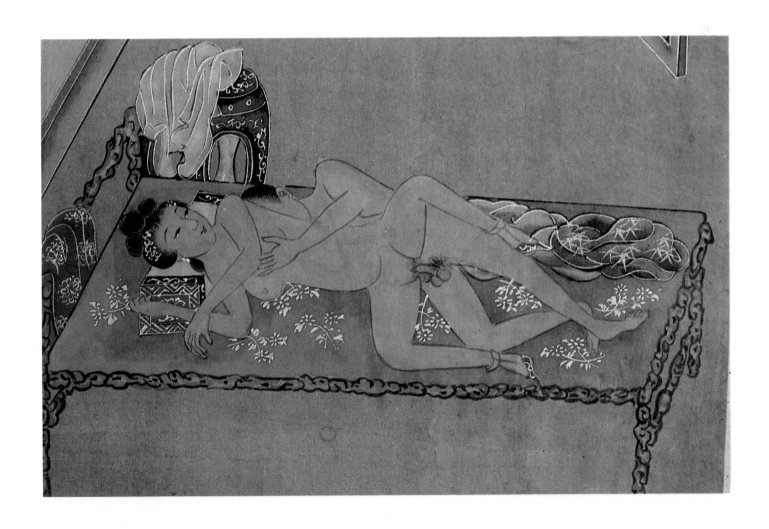

In this detail of a larger painting the
lovers perform the Taoist posture
known as Jumping White Tiger. The
contrasting skin tones, angular
composition, and fine details convey a
sense of power and sensitivity.

Tiny drops of sweat are like a hundred fragrant pearls,
The sweet full breasts tremble;
The dew, like a gentle stream,
Reaches the Heart of the Peony.
They taste the joy of love in perfect harmony.

(Chin P'ing Mei)

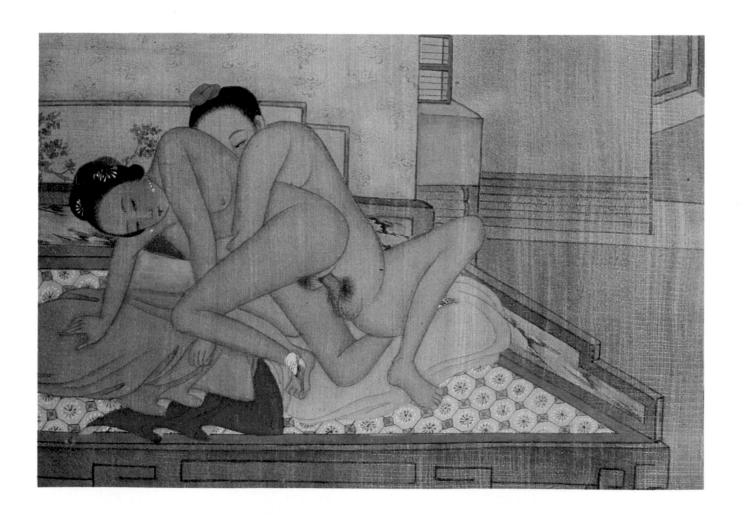

A Chinese couple are shown making love on a low bed, their movement caught as if frozen in time. As the man takes the active role, his partner turns on her side to complete a therapeutic love posture devised for the concentration of semen.

A Chinese couple make love in the classical Taoist posture known as Tiger's Tread. The lovers support themselves upon a bed, which has a mosquito net placed over a nearby rack. Flowers, books, and paintbrushes stand on a nearby table.

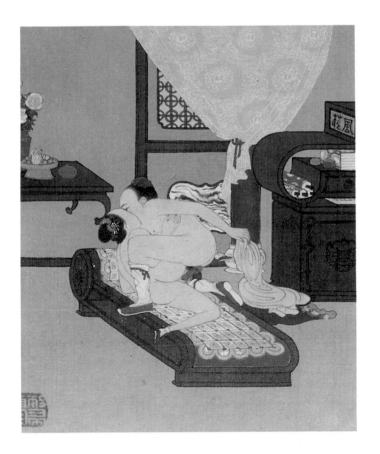

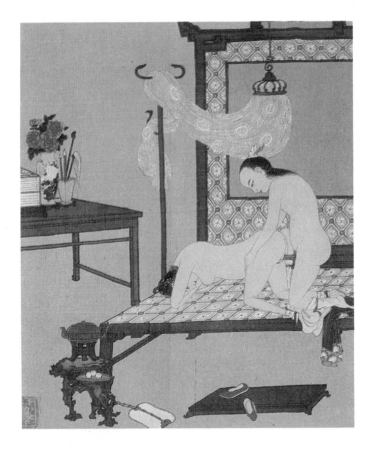

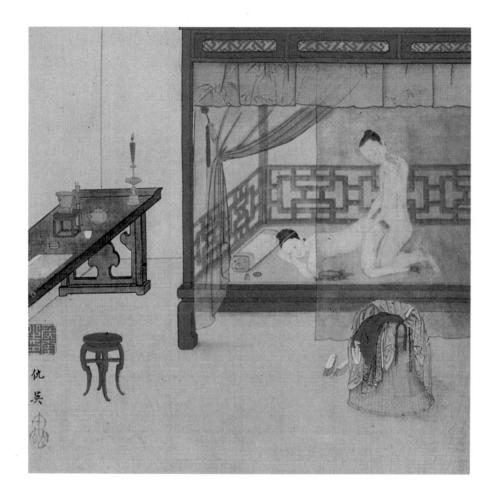

This exquisite scene shows a Chinese couple making love on a red lacquer canopied bed while a crimson candle burns nearby on a table. These lovers are performing the Taoist posture known as Jumping White Tiger, in which entry is made from the rear. Their pale bodies, glimpsed tantalizingly through diaphanous drapes, contrast with the vermilion color of the furnishings.

Vermilion bed, exquisitely curtained;
Flower tapestry adorning the wall.
Scented oil lamp shining brightly;
Beautiful women fill the palace with love.
(Ch'u Yuan)

A Chinese couple make love on a cream and red mat beneath a willow tree. In this detail from a fine water-color the lovers perform a variation of the Taoist posture known as Donkeys in the Third Moon of Spring. The old willow tree suggests constancy and longevity.

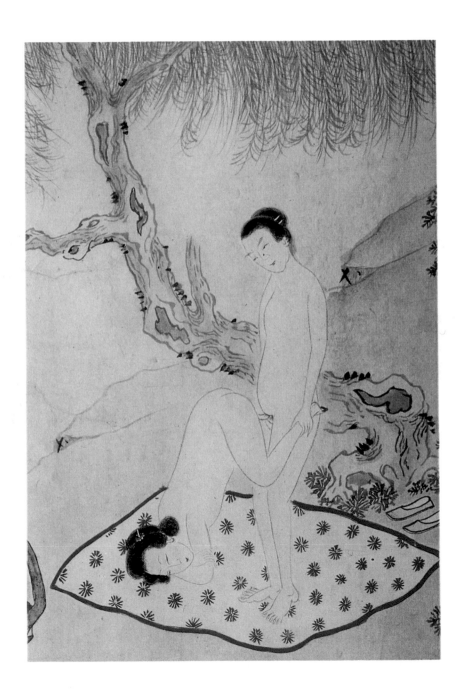

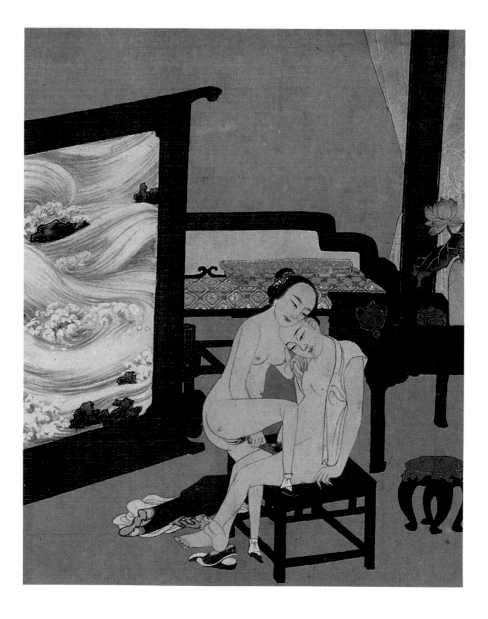

Chinese lovers are shown in dalliance before a beautifully painted screen of swirling waves, symbolic of torrents of passion. She takes his "Love Weapon" in her hand and brings it close to her "Pleasure Portal," to unite in a variation of the Taoist posture known as Shouting Monkey Embracing a Tree. The open lotus in a vase suggests the spiritual quality of their union.

A Chinese couple are seated on an ornate stool placed on a veranda decorated with red railings and a dragon column. The woman is seated upon her partner in the Taoist posture known as Mountain Goat Facing a Tree. The unusual use of gold to create elaborate motifs is particularly pleasing in this fine composition.

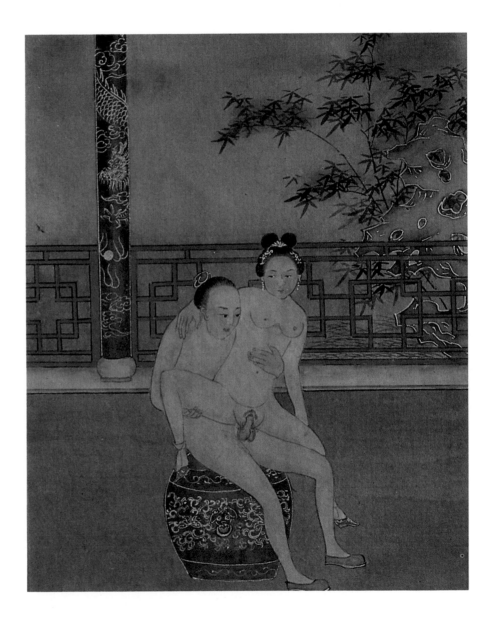

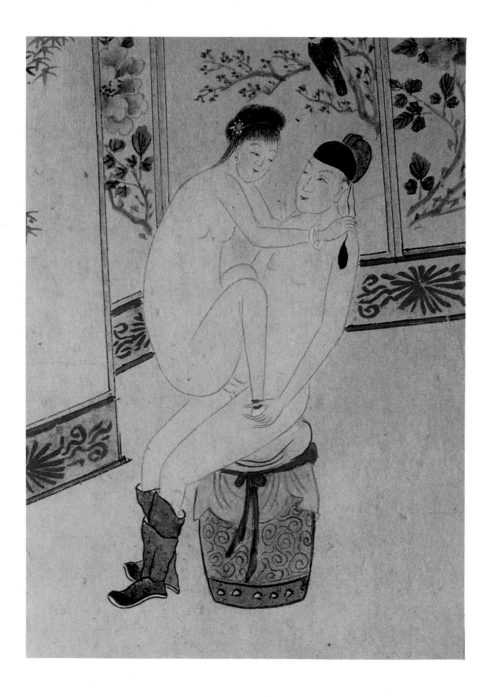

In this detail from a watercolor a Chinese couple are shown making love in a version of the Taoist posture known as Shouting Monkey Embracing a Tree. The man sits on a high stool sheltered by a screen exquisitely decorated with flowers and birds; his partner squats over him and gently lowers her "Love Cavern" over his "Warrior" while embracing him around the neck.

A Chinese couple make love within the confines of their house. The man embraces his partner around the waist as she squats upon his erect "Love Weapon." Their love posture is known as Mountain Goat Facing a Tree; the rejuvenative potential of this type of Taoist position is suggested by the bowl of sprouting bulbs in the foreground.

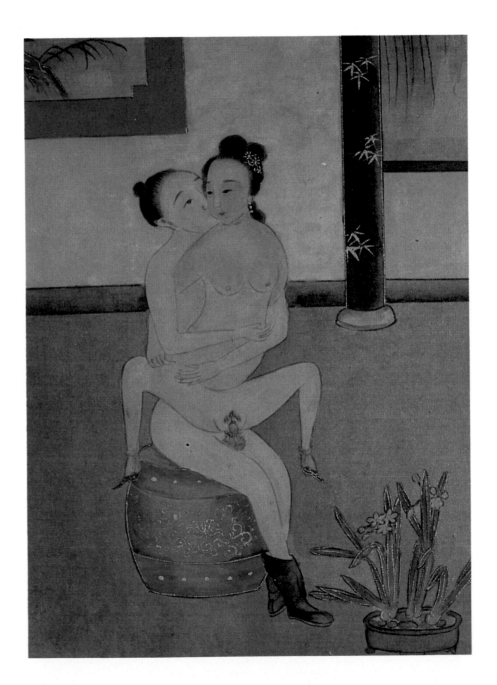

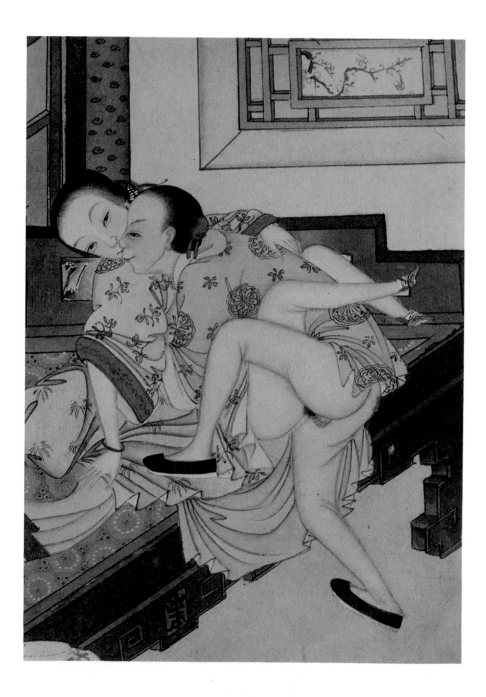

In this detail from a fine Chinese watercolor a richly dressed couple are shown making love in the classical posture known as Soaring Seagulls. The man approaches the bed as his partner wraps her legs tightly around his waist; drawing her to him, he inserts his "Jade Stalk" within her "Precious Gate." The delicate palette, tender expressions, and fine details make this a particularly sensitive study in eroticism.

She gently moves her slender hips;
He hastens to extend the Precious Scepter.
Then, with ears pressed close to listen,
They whisper sweet endearments of their love.
(Chin P'ing Mei)

A partly clothed Chinese couple make love in the Soaring Seagulls posture. The man stands and unites with his partner, who supports herself on crimson and blue pillows.

A couple make love in the classical posture known as Shouting Monkey Embracing a Tree. The man sits upright and unites his "Jade Flute" with her "Anemone of Love."

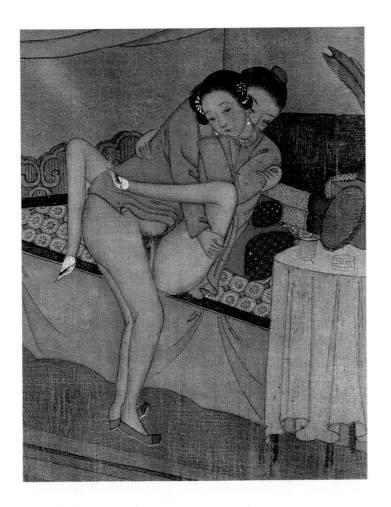

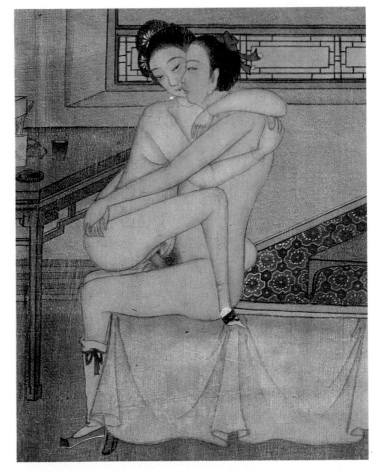

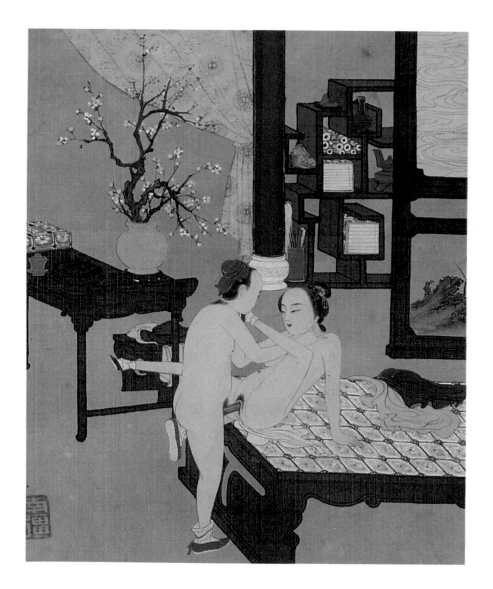

In another variation of the Taoist posture known as Soaring Seagulls a Chinese couple make love using a bed for support. Albums and scrolls fill the shelves next to a crimson column draped by a pink curtain. On a nearby table a vase of bursting blossoms suggests renewal and sudden awakening through the power of passion.

A Chinese couple make love in an outdoor setting. The woman leans backward on a bench, her feet raised high and suspended from the branches of a tree by silken cords. The man's "Jade Scepter" enters his partner's "Pleasure House" as he stands before her. This amusing scene delightfully illustrates the joys of spontaneous innovation in the "Battle of Love."

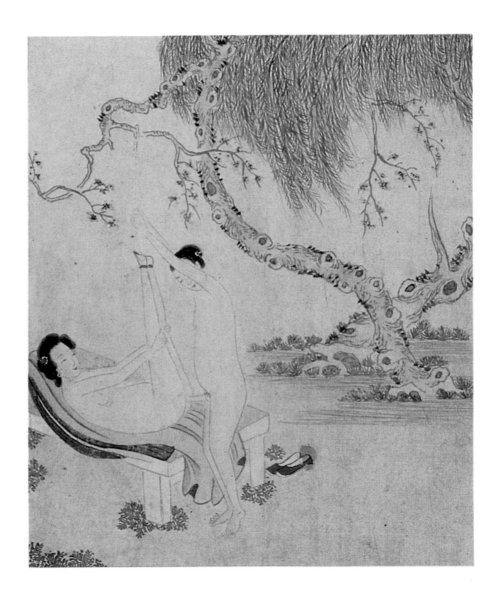

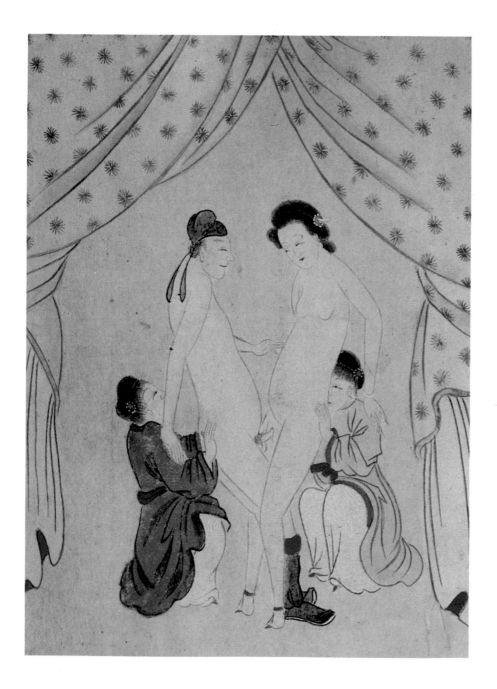

Here an extraordinary love rite is revealed. A naked Chinese noble couple stand and make love in the classical Taoist posture known as Bamboo near the Altar; their bodies are supported by two servants, who aid in their movements of love. The stark whiteness of the naked bodies contrasts with the pink and blue robes of the servants; a yellow floral canopy is carefully draped into sensual shapes, adding to the mood of eroticism.

This Shunga *painting shows two distinct erotic scenes. To the right side of a screen a Japanese couple unite together in a seated love posture, the woman arching her naked white body* toward her partner as he caresses her left breast. To the left of the screen a solitary woman fondles her "Jade Gateway."

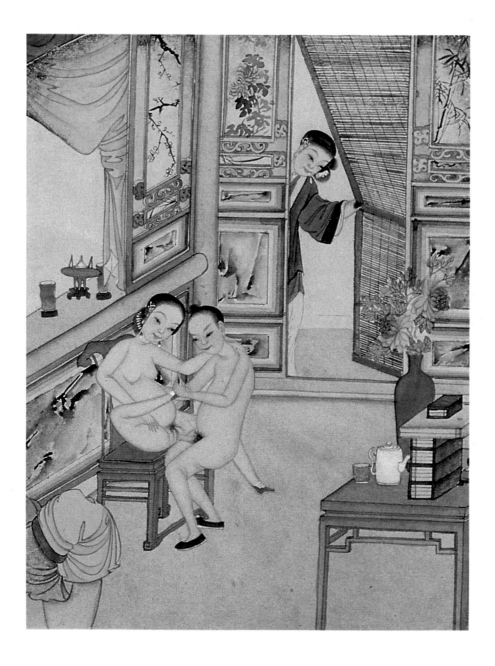

This fine watercolor depicts a Chinese couple making love within an elaborately decorated room. As the woman sits on a chair, her partner stands before her and unites his "Jade Stalk" with her "Precious Peony"; a second woman peers into the room.

It is ten times more pleasant to make love during the day than at night. The particular attraction lies in being able to behold the other's nakedness, for such a sight increases the desire.

(Jou Pu Tuan)

In this rare Shunga *painting a Japanese man and two women make love in a classic version of the posture known as Two Dancing Female Phoenix Birds. The* *focus of the composition is the greatly enlarged "Faithful Servant" as it enters the "Precious Conch Shell" of the uppermost woman.*

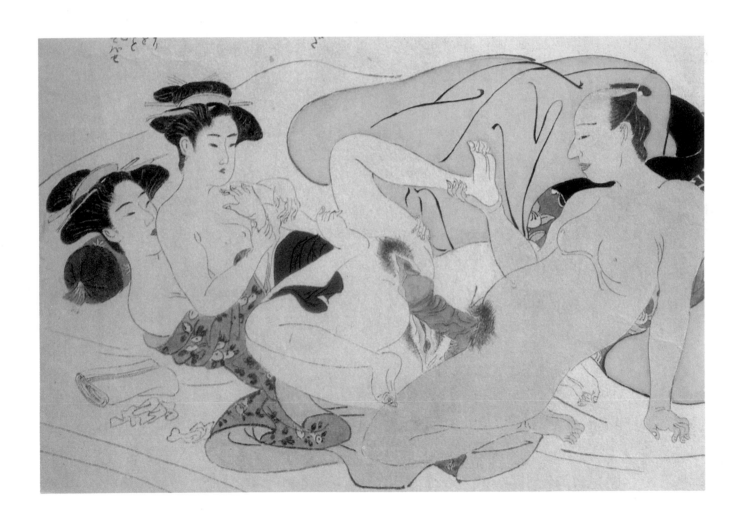

Here an interior scene is shown involving a single Chinese man with two women. The man kneels and approaches the exposed "Mysterious Gateway" of a woman who sits on a chair while a second woman, wearing only a small crimson apron, stands in attendance.

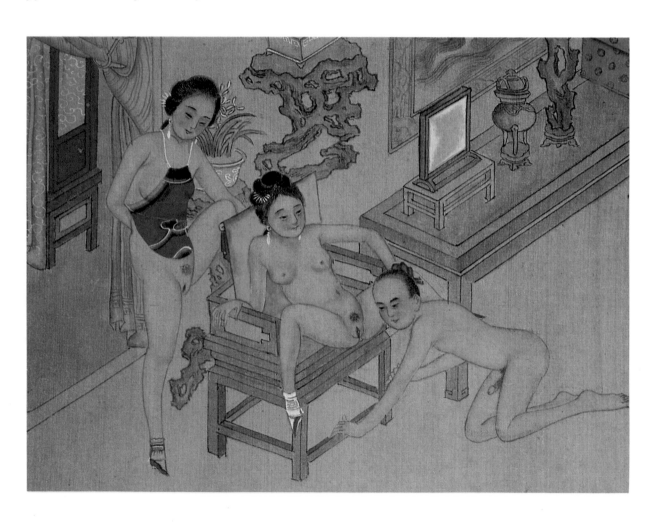

In this detail a Chinese man makes love with two women simultaneously, while seated upon a wooden bed. As he unites with one woman in the Taoist posture known as Mountain Goat Facing a Tree, the man uses a sexual aid to satisfy the second woman, whom he is also kissing. In Chinese polygamous society, techniques were developed to enable a man to satisfy each wife or concubine while circulating the sexual energy among all participants.

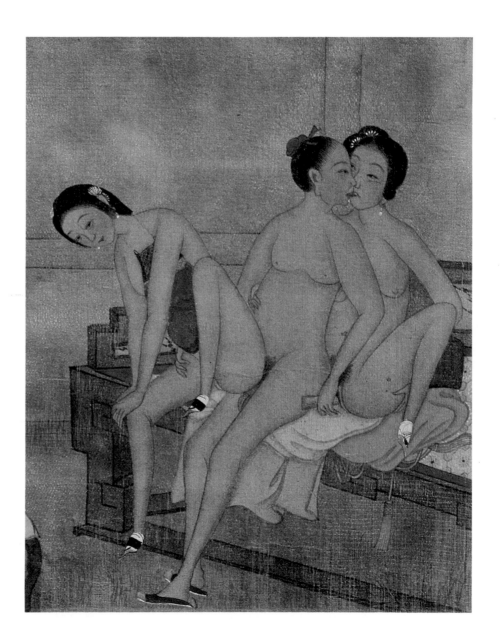

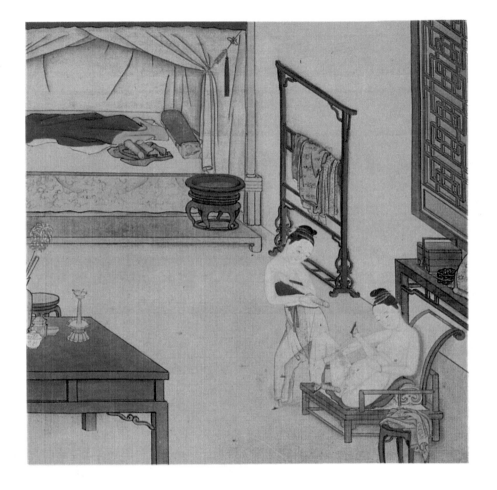

Two Chinese women are shown in a moment of intimacy. One sits naked in a low chair, a substitute phallus attached to her heel for self-gratification, while the other woman stands nearby, holding a second one. In Chinese culture such sexual aids were often employed in a harem setting.

A Chinese man kneels on a bed and prepares to make love to two women, one of whom caresses his "Jade Stalk" while the other leans back with thighs apart and arms around his neck. It seems they are preparing for the Taoist posture known as Jungle Fowl. The muted colors and delicate treatment of facial expressions helps convey a mood of sensitive eroticism.

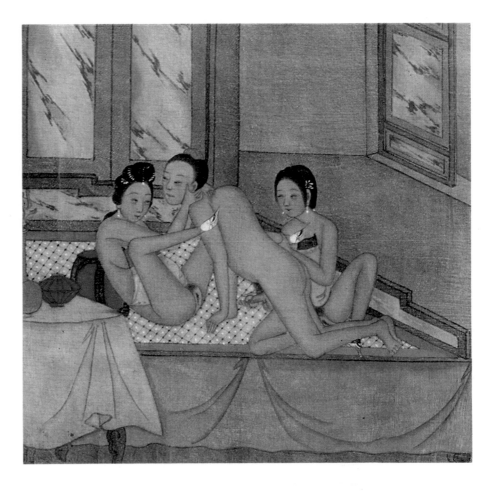

Sometimes each Peony in turn
Slept with him until dawn;
Sometimes both shared him
Until midnight;
Finally, all loved each other
As the three came together as one.

(Chao Hen)

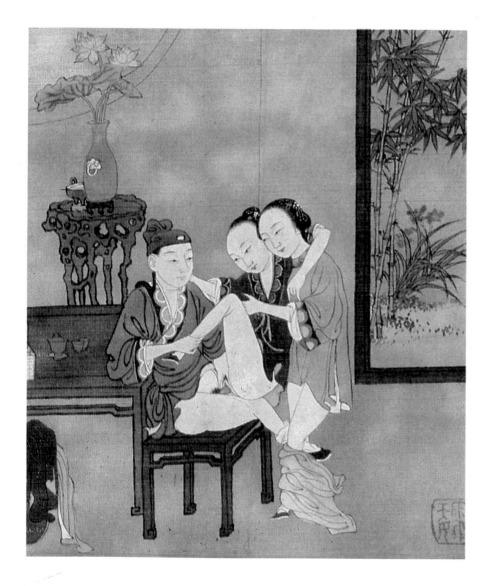

A partially dressed Chinese man is seated on a chair within an exquisitely decorated room. One woman lowers her "Cinnabar Crevice" over the man's "Positive Peak," assisted by a second partly clothed standing woman. This scene probably depicts a nobleman with two of his wives; the two blooming lotuses visible in a vase behind subtly suggest the satisfaction of both.

In this detail from a larger painting
two naked Chinese women are shown
seated on an ornate chair, one holding
the other so as to allow penetration of
the "Purple Peony" by the "Yang
Pagoda" of the standing naked man.
This scene may represent a husband
with two wives or perhaps the sexual
initiation of a young courtesan. The
bonzai tree in the foreground symbolizes
longevity, here realized through the
successful harmonization of the Yin
force of femininity.

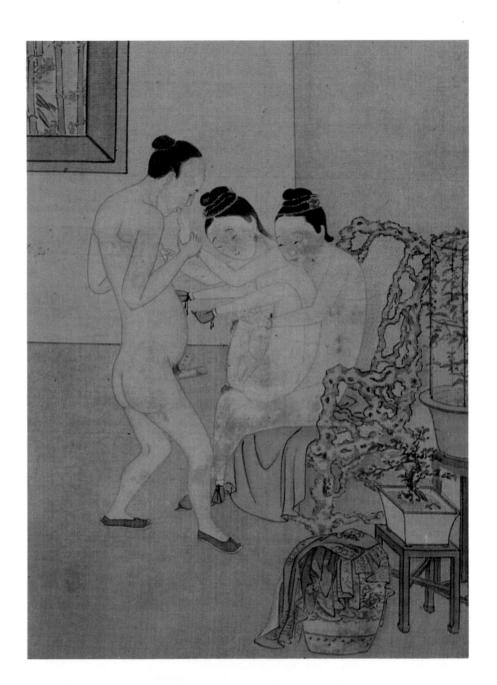

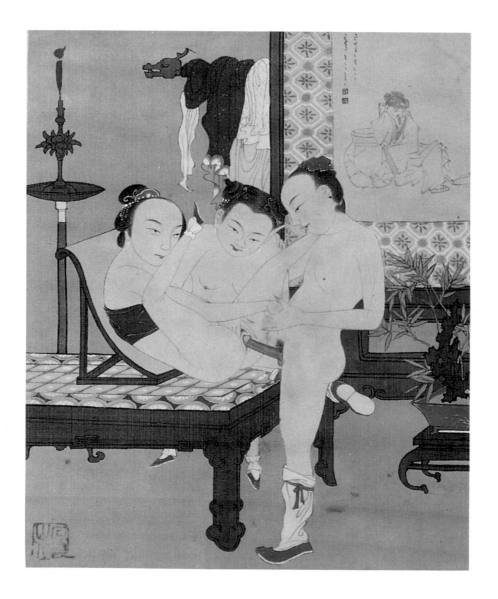

A Chinese man stands before a couch and inserts his "Positive Peak" into the "Honey Pot" of a woman supporting herself against a special back rest; a second woman assists as a crimson candle burns brightly to one side. The pot of bursting bamboo shoots, dragon-motif hanger, and portrait of a Taoist sage on the screen behind all suggest that this "secret dalliance" is an ancient rite for longevity.

A Chinese man stands before a couch and gently enters the "Secret Cavern" of one woman with his "Crimson Bird" while probing the "Pleasure Portal" of a second woman, who exposes herself to him. Despite the plurality of this union, no trace of jealousy can be seen on the faces of the women. The color composition of this painting is particularly effective in conveying the mood of intimacy.

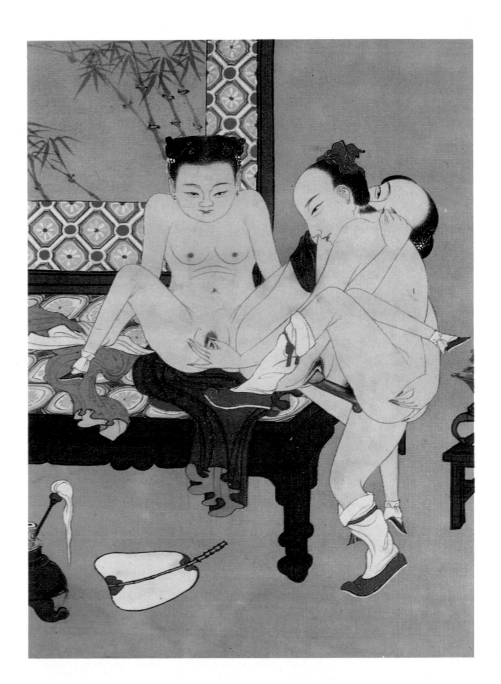

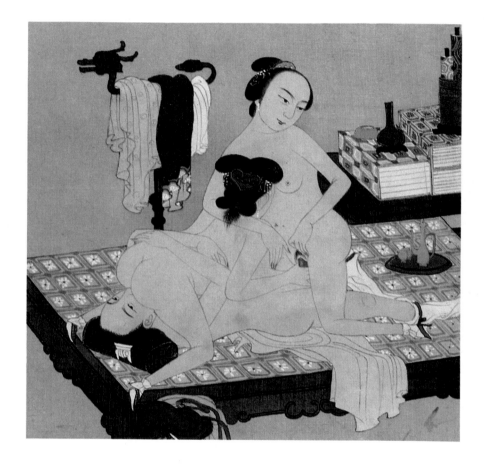

A Chinese man reclines upon a couch and unites with one woman in a therapeutic love posture for "increasing the blood" while practicing oral love with a second woman, who sits over him and caresses his "Jade Scepter" as it moves within the "Anemone of Love." A pyramid of forces is created by the conjoined bodies. Pillow books are piled high on a nearby table.

There is a Secret Dalliance known as the Heavenly and Earthly Net whereby people indulge in sexual play like the birds and beasts, many females with a single male.

(Tao An)

The dalliance scene has moved to a mat on the floor. A partly clothed Chinese man kneels before a reclining woman and probes her "Golden Crevice" with his tongue while a second woman sits in attendance. The subtle relationship of colors in this painting conveys a mood of intimate sensuality. Flowers blooming in a vase and on a screen near a crimson column symbolize the sexual satisfaction of the woman and the virility of the man.

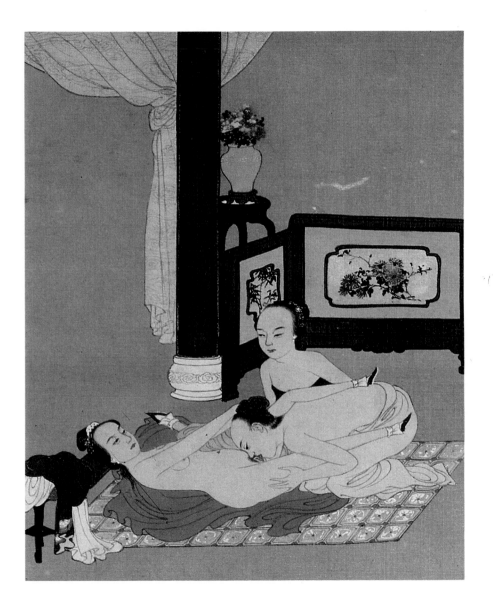

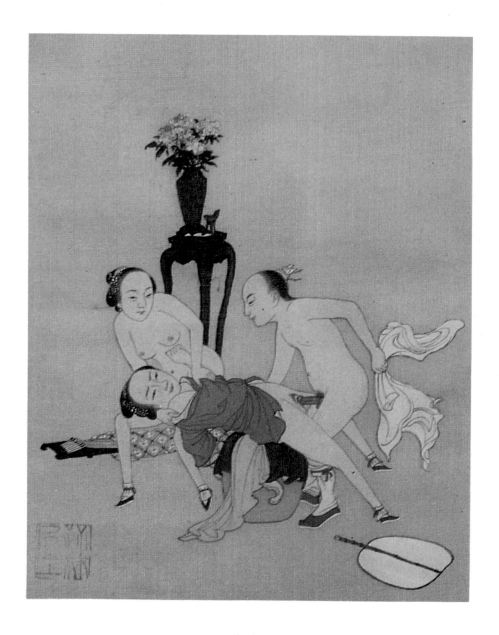

In this delicate Chinese painting a man unites with one woman who is partly supported by a second woman. This is a variation of the Taoist posture known as Queen Bee Making Honey. The pink flowers blooming in a vase over the heads of the participants suggest sexual satisfaction.

This depiction of Taoist love dalliance of the type known as *Feast of Peonies* shows a Chinese man reclining on a mat while two women make love to him; as one lowers her "Precious Flower" over his "Jade Stalk," the other presents her "Pleasure Grotto" to his mouth. The two blooming peonies in a jade dragon-motif vase emphasize the symbolic aspect of this sexual practice, designed to enhance the vitality of all participants.

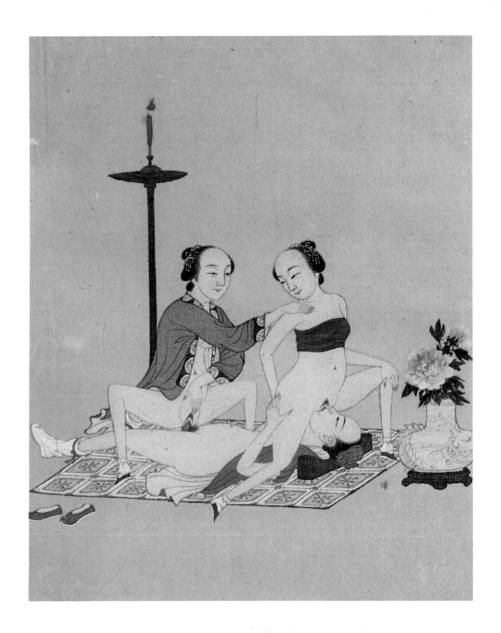

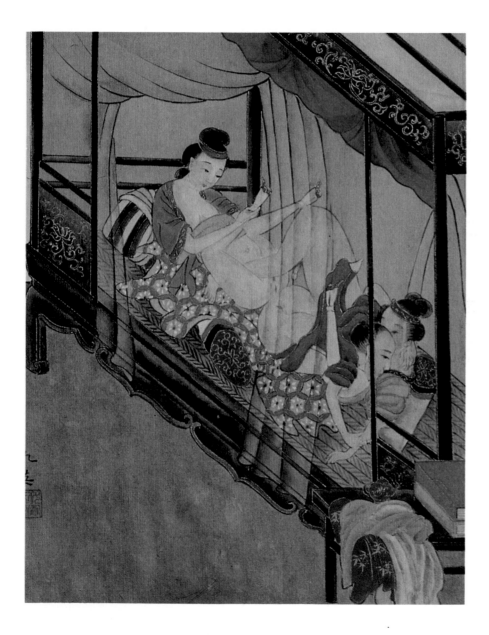

A Chinese man makes love with two women in an exotic canopied bed. They seem to be practicing a variation of the Taoist posture known as Two Dancing Female Phoenix Birds; discarded clothes and a pair of pillow books rest on a table in the foreground. A feeling of spontaneity is expressed by the clever use of color and composition.

A Chinese couple are shown making love on a bamboo bed while a maidservant stands behind them and assists their love movements. This form of erotic dalliance is a version of the classical Taoist posture known as Jungle Fowl.

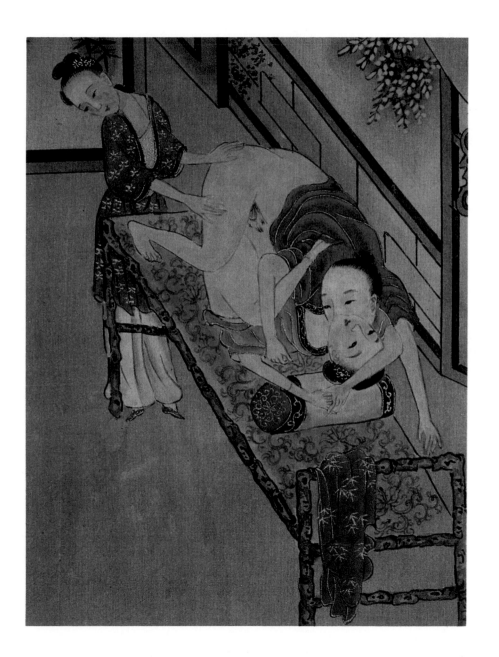

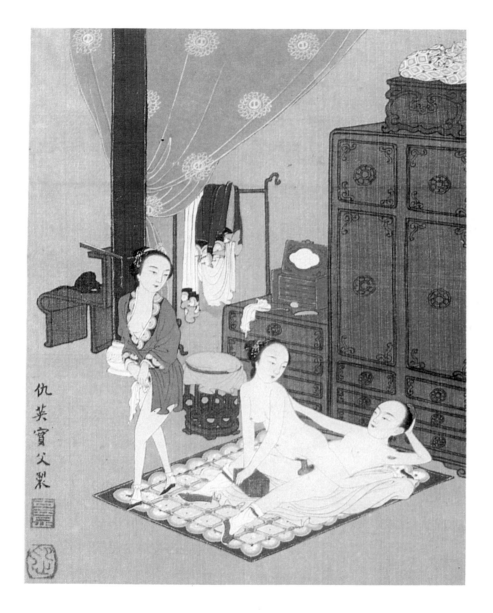

A Chinese man reclines on a sleeping mat as a woman straddles his body and performs the classic posture known as *Reversed Flying Ducks*. A second partly clothed woman is shown walking away from the scene, holding a love-cloth in her hands. Ornate cabinets are portrayed in the background.

A Chinese couple lie in close embrace upon a bed decorated with carvings, hangings, and paintings of blossoms. They are in the posture known as Pair-Eyed Fish and kiss each other on the lips. The contrasting skin tones complement each other and contrast with the crimson covers and blue borders of the bed.

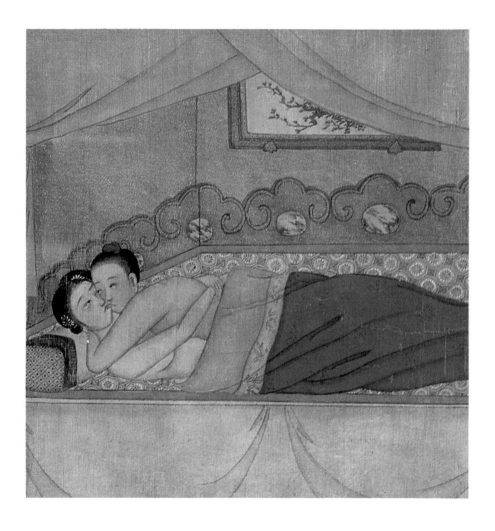

We slip beneath the silken covers,
All warm and scented; our moment comes,
The dew falls; the Precious Flower opens
In the tenderness of love; the Clouds
and the Rain complete us, complete us.
 (Huang Ching)

INDIA
AND NEPAL

Once the Wheel of Love has been set in motion, there is no absolute rule.
(Kama Sutra)

This exquisite painting shows a richly
dressed Maharaja seated on the terrace
of his palace while he playfully fondles
his beautiful consort; the lotus crown
on his head suggests a high level of
spiritual attainment. As he leans
against sumptuous cushions, his partner
clasps her arms around his neck and
gazes at his face adoringly. The fresh,
clean mineral colors of this composition
create a mood of natural harmony.

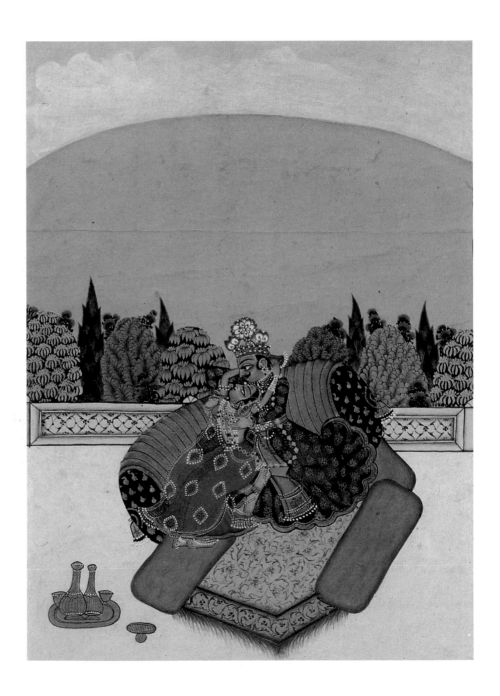

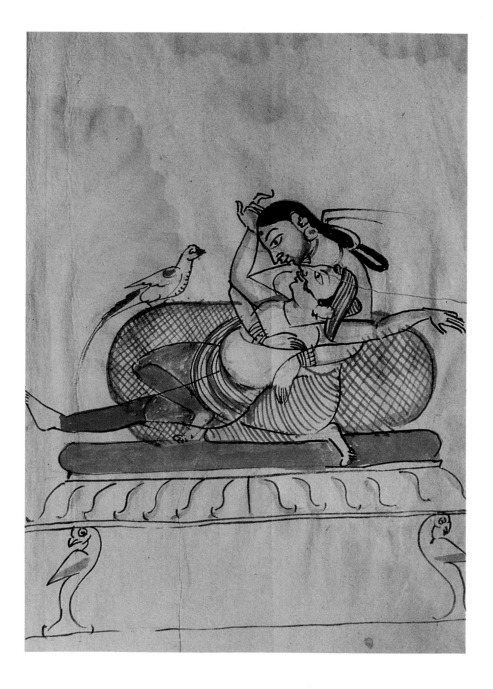

This lyrical watercolor depicts a nobleman reclining in the arms of his beautiful consort, who shares an ornate cushioned couch with him. The parrot perched on the pillow symbolizes Mohini the Temptress. The flowing spontaneity of line and color shows a real mastery of technique.

83

This fine watercolor depicts a man reclining on a couch while his consort squats upon him in the Tantric love posture known as Bee Buzzing over Man, described in the Ananga Ranga. The woman holds a lyre and makes sweet music while loving her enraptured partner.

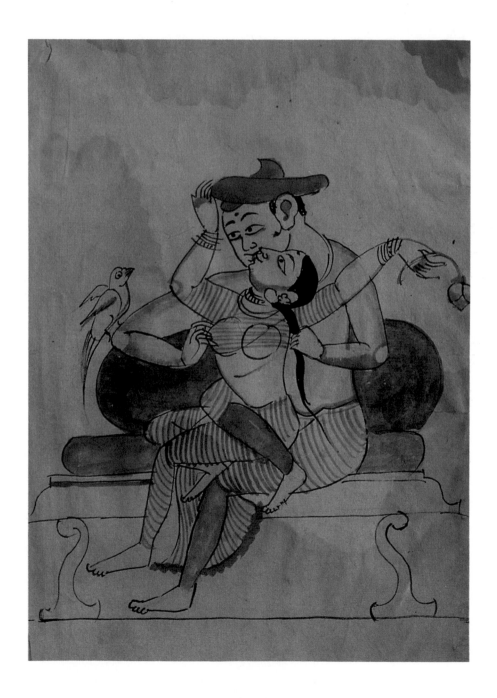

A noble couple are entwined upon a love seat while a parrot perches nearby. As the woman holds a lotus bud, symbolic of spiritual passion, she looks lovingly at her partner, who fondles her breast. The mood of this flowing composition is joyous.

A couple make love upon a couch. He leans over his partner, allowing his **Lingam** *to enter her* **Yoni**; *she encourages him and holds a lotus in her right hand. A feeling of ardor is lyrically conveyed through the free yet economic use of line and tone.*

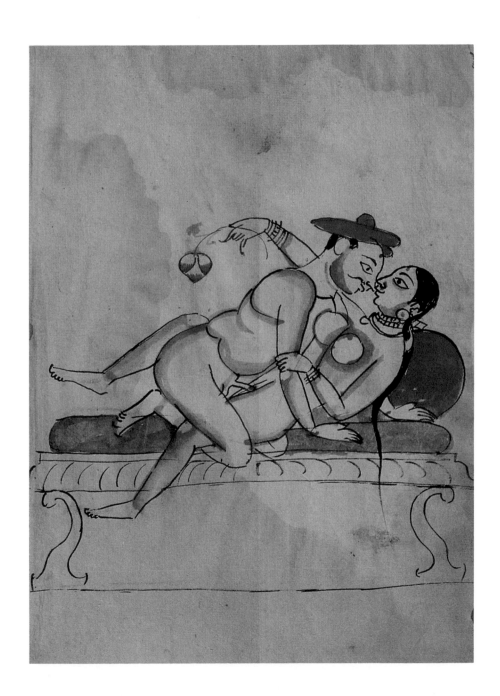

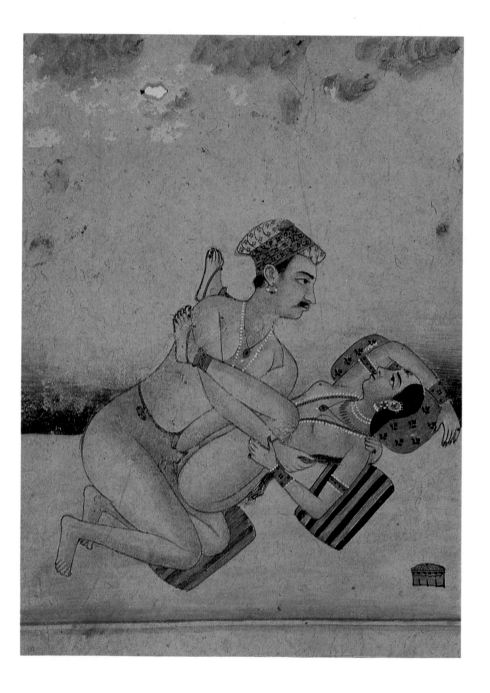

A noble couple are shown in the first stage of the Indrani posture, as described in the Kama Sutra. The woman leans back, as her lover enters her Yoni. A small gold box, probably for betel nut, is shown at one side. The fine line and light color wash create an atmosphere of reserved refinement.

A nobleman kneels formally as he makes love to his beautiful consort in a variation of the classical Turning Posture. As the woman turns around to face him, she fans him from behind. The exquisite gold and red details contrast greatly with the light color wash of the composition.

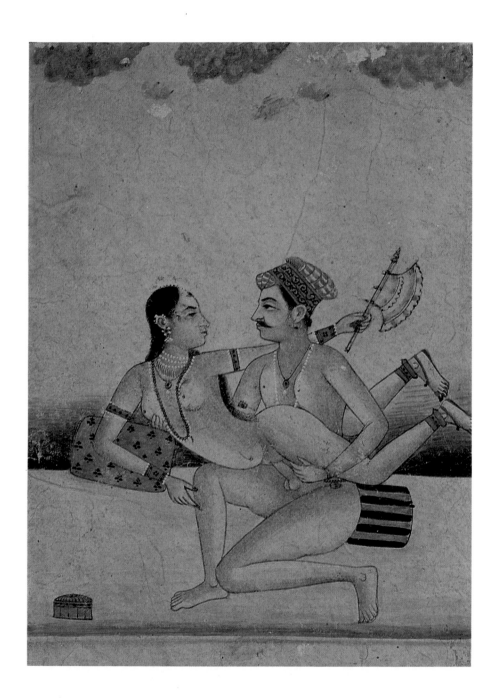

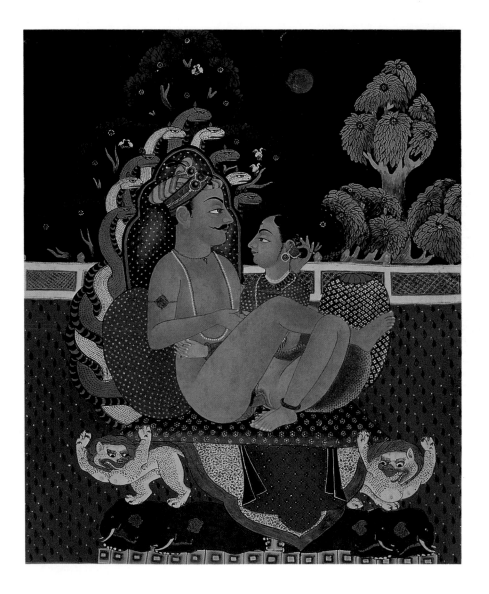

In this rare and beautiful painting a Nepalese king is depicted in the role of Vishnu, the Hindu Lord of Preservation and Ruler over the erotic sentiment. His consort is shown as Lakshmi, goddess of prosperity and auspiciousness. This regal couple are in seated union upon a high throne supported by snow lions and elephants; a canopy of snakes rears up to protect them. Beyond, a pale full moon hangs in the dark night sky and illuminates the garden. The painting is inscribed Siddhi Narayan, meaning "The magical power of Vishnu."

A noble couple makes love on a palace terrace, a dark stormy sky overhead. The man kneels on one knee and aims an arrow at a white crane flying over-head; a sword and shield lie discarded at his feet. A naked consort sits in union upon him, her head turned toward his target. The bow and arrow bring to mind Kama Deva, the Hindu love god who, like Cupid, shoots "arrows of desire."

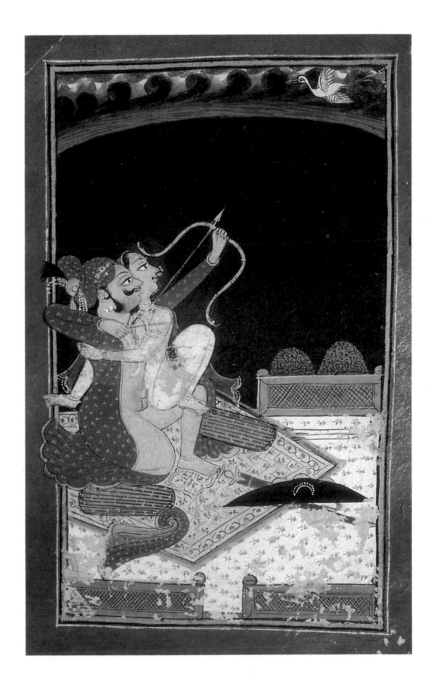

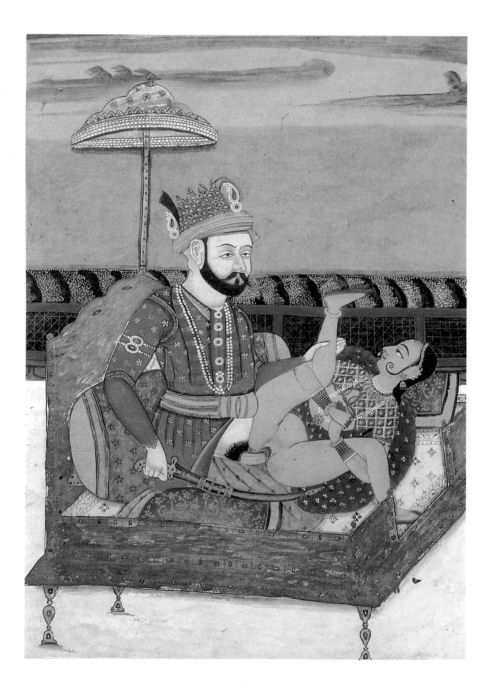

This Nepalese painting depicts Nadir Shah—the great Persian ruler who sacked Delhi and captured the Peacock Throne—seated in union with a beautiful woman whose hands and feet are red with henna. Perhaps he is "conquering Delhi" (symbolized by his Indian partner), since he sits on the Peacock Throne and holds a sword in his right hand. His consort seems to be an adept of sexual yoga, for she holds her legs with her hands in a way designed to harness the outward flow of sexual energy.

This exquisite detail from a Nepalese painting depicts Badshah Jehangir and Begum Nur Jahan seated in union upon the Peacock Throne which rests on the terrace of a palace. As these famous lovers unite their bodies in the Gaining-Restraining posture of the Ananga Ranga, *they look lovingly into each other's eyes. The rich colors and fine details give a regal air to this magnificent composition.*

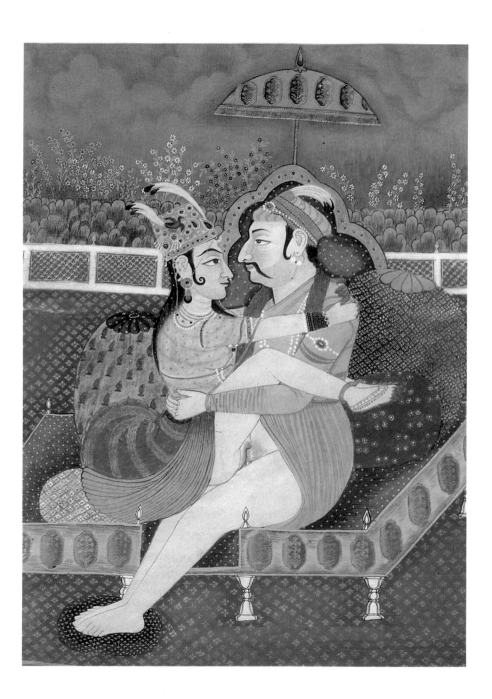

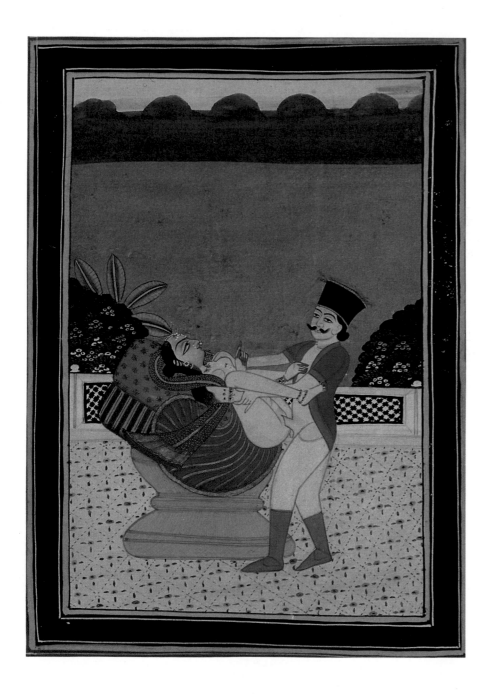

A man wearing a soldier's uniform stands on a palace terrace and makes love to a noblewoman who supports herself on a high podium and cushions. The woman's almond-shaped eyes gaze upward as her partner takes the active role. The delightful combination of yellow, orange, and cream contrasts exquisitely with the cool silver and blue of the sky behind.

A noble couple make love in a covered pavilion as a maidservant waits in attendance. They are performing a variation of the Supported Position of the Kama Sutra. Storm clouds loom in the sky and contrast with the fresh, bright colors of the main composition.

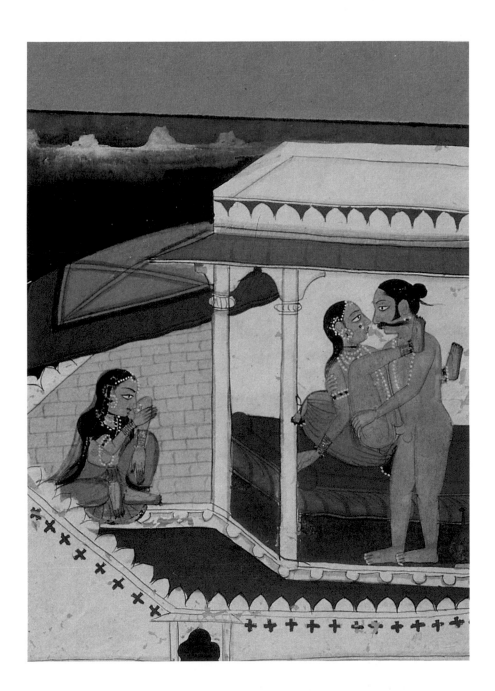

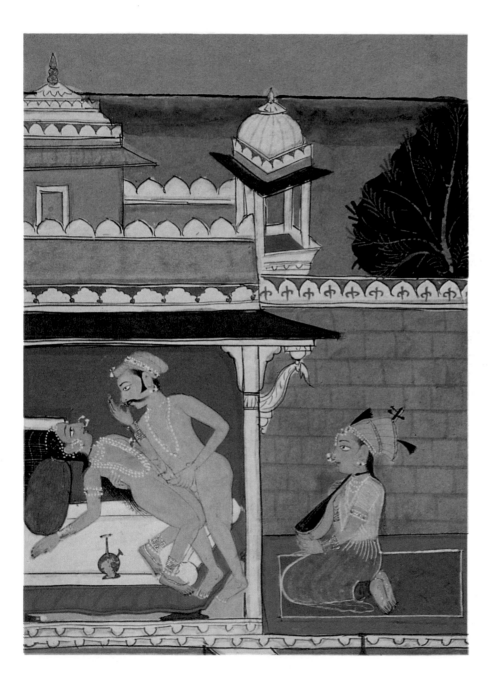

A noble couple unite in a red room adjoining a walled terrace. As the man holds his Lingam and places it within the Yoni of his beloved, she leans back over a white bed and playfully twirls his moustache with her hennaed fingers. A female musician kneels on the terrace outside, providing sweet melodies to accompany the movements of love.

In this detail from a miniature paint-
ing of the same series as the previous
two plates, a noble couple unite in the
standing position known as Three Steps
of Vishnu.

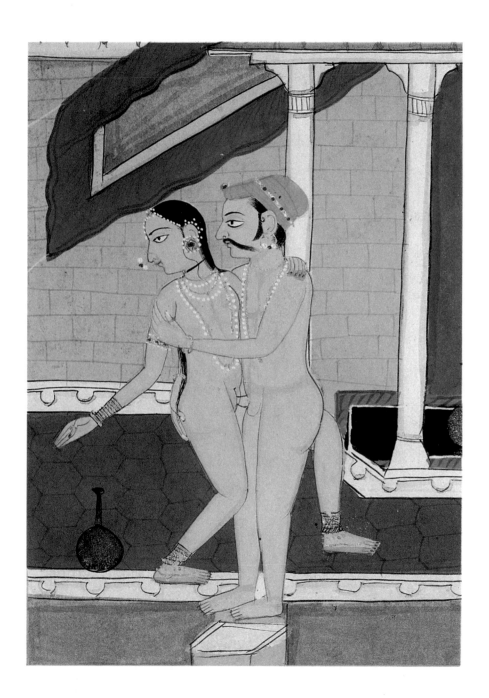

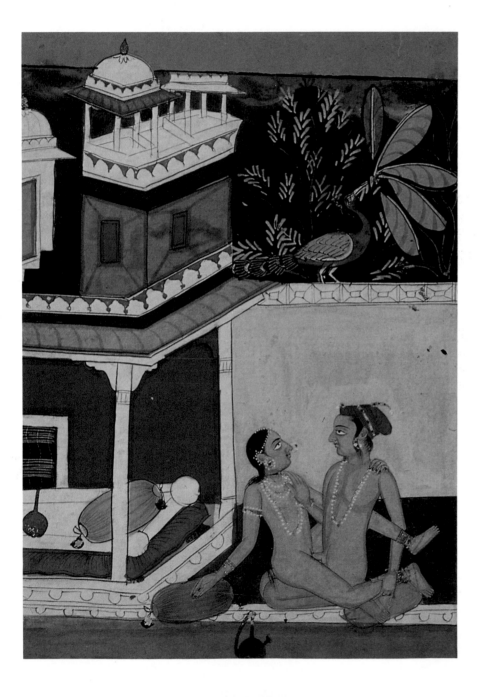

From the same series as the previous four examples comes this depiction of a noble couple in seated union on the terrace of a palace. A peacock struts on a wall while the lovers rock backward and forward, placing their hands in mystic gestures devised to channel sexual energy.

An Indian couple are seated indoors in the Lotus Position of the Ananga Ranga. The man's face carries an impassive expression as he concentrates on retention; the woman's long braid falls down her back like a thin black snake. The skin tones contrast well with the palette used in the rest of the composition.

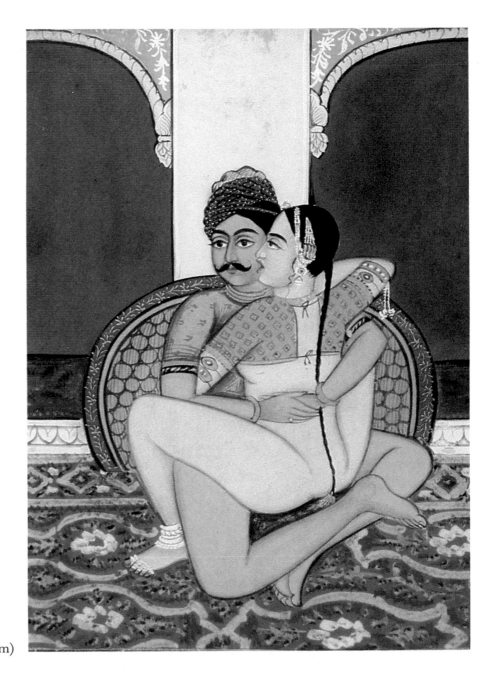

When both are locked in the embrace of love,
There is no separateness, no "good" or "bad";
All thoughts vanish
With the onslaught of pure passion.
(Kuttni Mahatmyam)

This interior scene depicts a dark-skinned Indian man uniting with a fair Indian woman with hennaed hands and feet. They are performing the Equal Peaks position of the Moon Elixir Tantra, devised to allow sustained rocking movements condusive to achieving ecstasy.

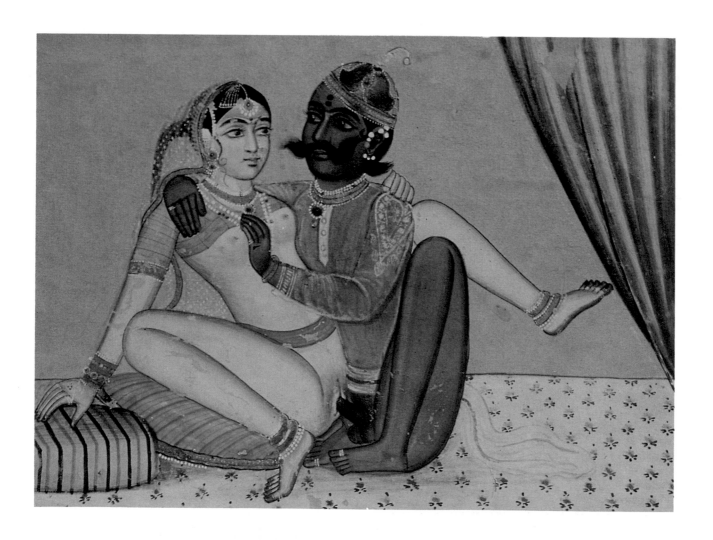

In this detail an Indian couple unite within the confines of a house. The man squats and holds his Lingam to his partner's Yoni as she leans back on crimson cushions. The woman's naked body is covered with fine jewelry and her forehead bears a red mark. This couple are performing a version of the classic Indrani posture of the Kama Sutra.

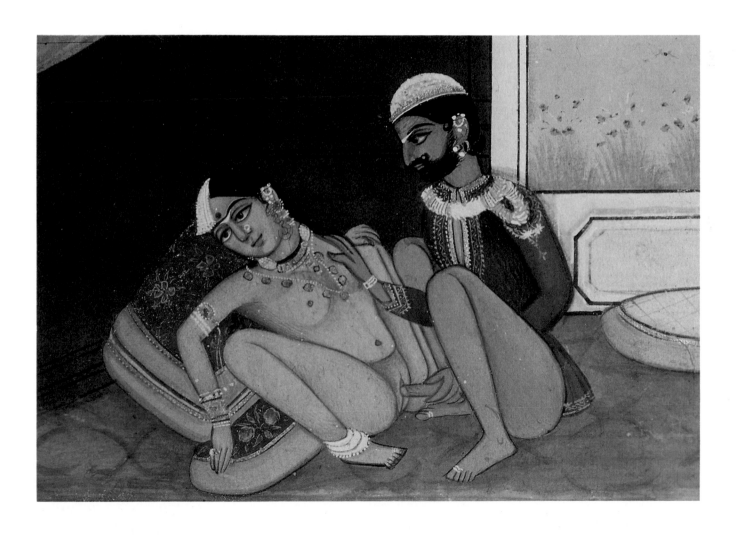

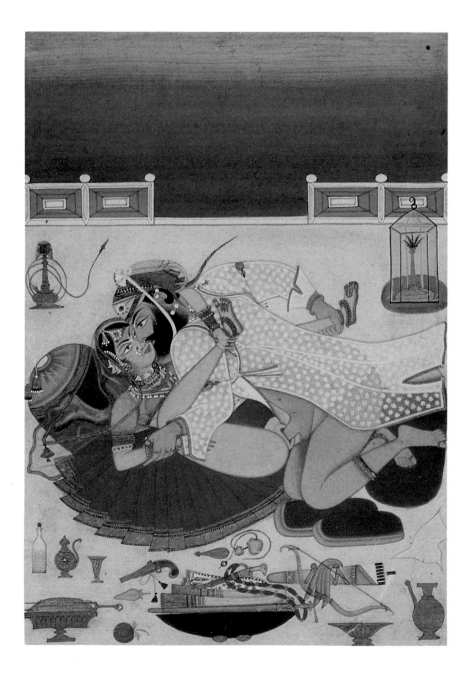

A Hindu Maharaja kneels in full regalia in erotic union with his consort on a palace terrace. This noble couple are performing a version of the classical Indrani posture. The woman's hands and feet are ritually hennaed. She is exquisitely adorned and as she leans back upon cushions her vermilion skirt opens like a fan, contrasting with the white robes of the ruler. In the foreground are displayed weapons, ritual items, and refreshments; a bird cage and a hookah are shown behind. Beyond, on the horizon, greens melt into blue; nature becomes celestial.

This intimate view inside a palace shows a Hindu Maharaja kneeling upon a bed and entering his consort's body as she raises her legs in the classic love posture known as Alternate Yawning. The couple gaze intently into each other's eyes while a female attendant moves a fly-whisk over them and aids their love movements by rocking the bed. The use of the comple-mentary colors of lilac and yellow ocher, red and green, instills a mood of harmony and psychic upliftment.

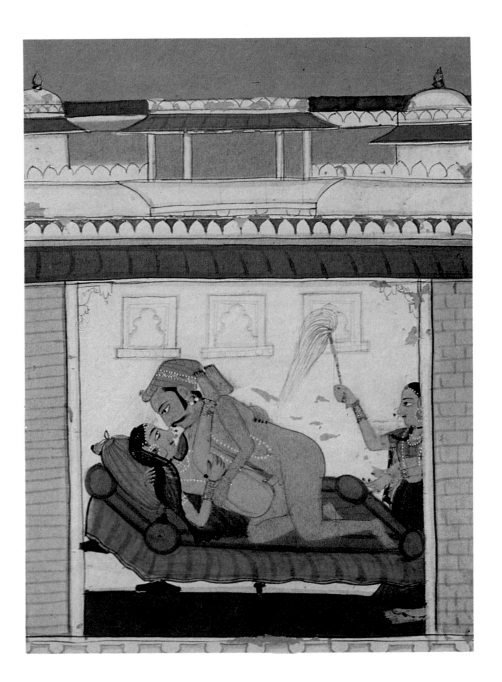

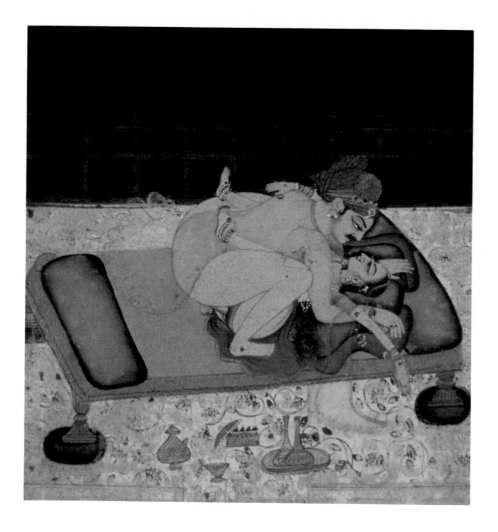

The ecstatic union of a regal couple is beautifully portrayed in this detail. A Maharaja squats over his consort, penetrating her as she lies back on a bed placed on an outside terrace. As the man moves his "Scepter" within his partner's "Lotus," he gazes intensely into her eyes and performs the Bird Position described in the Ananga Ranga. This is perhaps a Tantric rite performed in the dead of night.

How delicious an instrument is woman, when artfully played upon; how capable is she of producing the most exquisite harmonies, of executing the most complicated variations of love, and of giving the most Divine of erotic pleasures.

(Ananga Ranga)

This exquisite Nepalese painting depicts a royal couple in the Mounted Yantra posture of the Moon Elixir Tantra. The mood is filled with romance as the lovers unite under the moon and stars. The combination of textures and designs contrasts beautifully with the colors and tones of the composition and helps convey a sentiment of sweetness and passion.

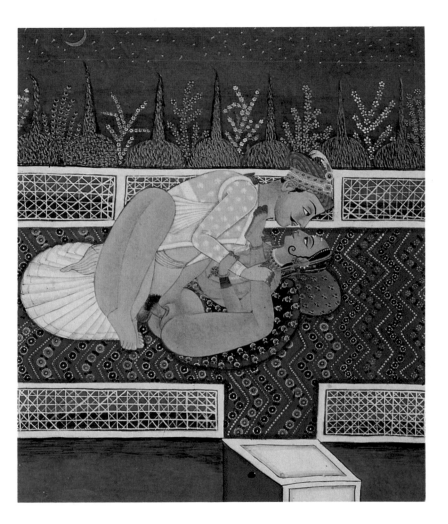

This detail of an exquisite painting depicts a noble couple making love on a palace terrace. The man kneels, with the woman seated on his lap in the Roaring posture described in the Ananga Ranga; *as they rock back and forth they gaze lovingly into each other's eyes. Roses bloom against the evening sky in the background, and refreshments are close at hand.*

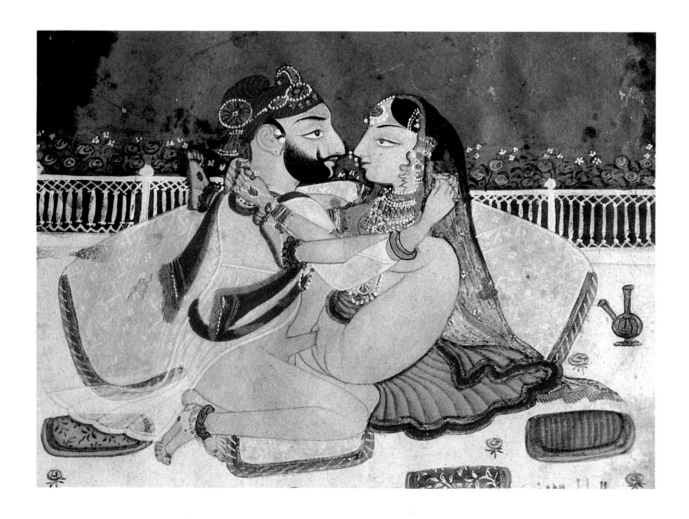

A noble couple unite upon the terrace
of a palace. They have formed their
bodies into a mystic love posture,
linking hands and raising up their legs
to create an upliftment of sexual
energy. An aureole of celestial color is
visible behind the man's head,
symbolizing the spiritual fruit of such
practices.

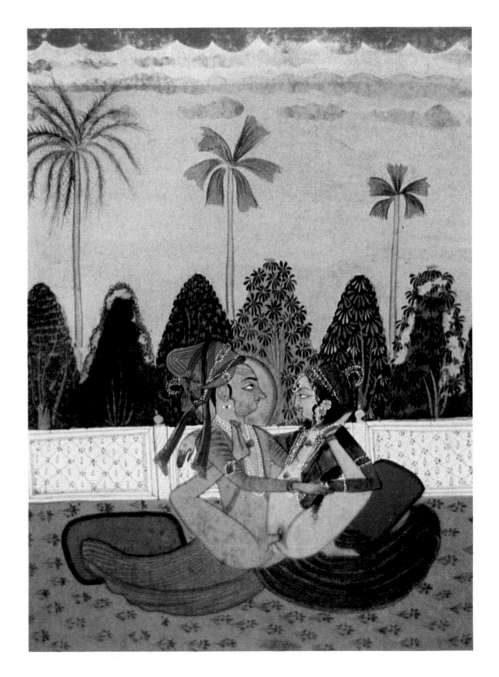

The wife is half the man, his priceless friend;
Of pleasure, virtue, wealth, his constant source;
A help throughout his earthly years;
Through life unchanging, even beyond its end.
(Mahabharata)

In this detail a noble couple are shown seated in Tantric union upon a white bed within a red room. The couple embrace and make love in a version of the Thigh-Rubbing posture of the Moon Elixir Tantra. As the man clasps his partner's leg, she holds up a cup of wine.

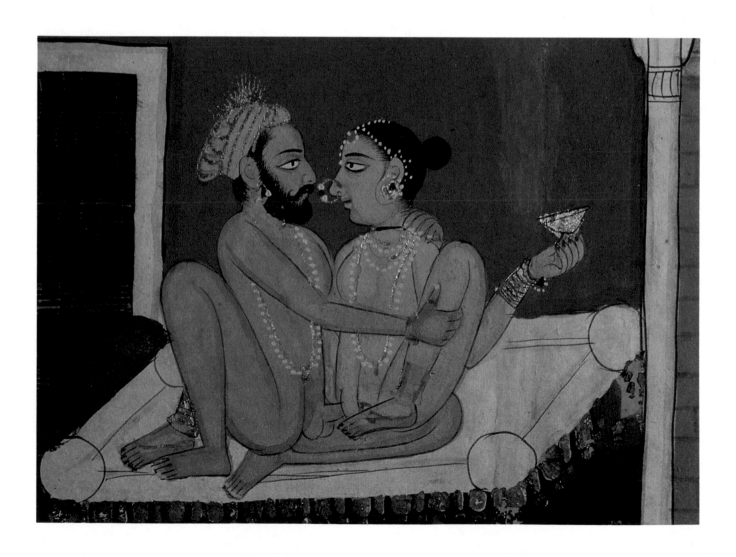

Another seated love posture is shown in this detail from the same series as the previous example. The couple perform the Gaining-Restraining position described in the Ananga Ranga and rock their bodies back and forth underneath a blue and red canopy.

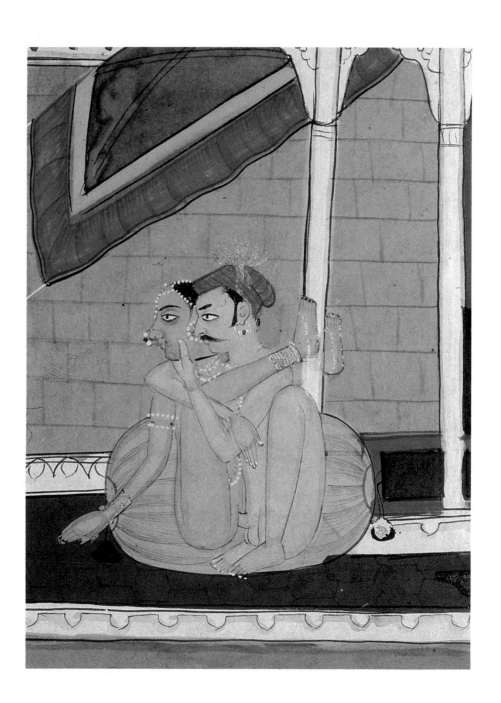

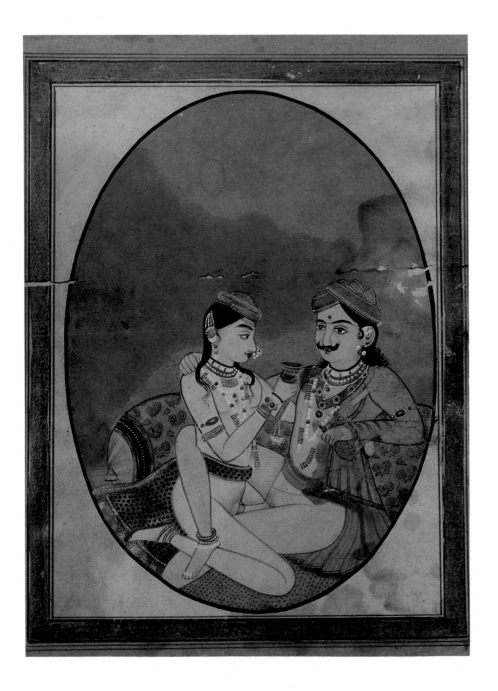

An oval vignette frames a pair of noble lovers who are seated in a version of the Gemini Position described in the Ananga Ranga. The man leans back on a large pink cushion, his Lingam slightly withdrawn from the Yoni, while his consort raises a cup of wine to his lips. The expanse of blue behind them adds an almost celestial quality to this exquisite composition.

109

Maharaja Rajdullah Bahadur is shown in this detail from a Nepalese painting. He is seen kneeling on a throne while uniting with a favorite concubine and smoking a hookah. Together they are performing the Widely Open posture described in the Kama Sutra. The complementary colors of red and green and blue and orange provide a vibrant contrast to the white robes and pale complexions of the couple.

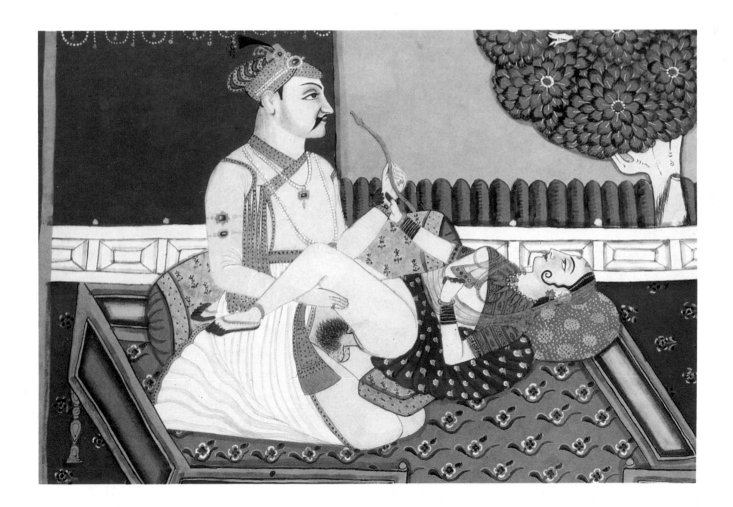

A noblewoman takes the active role in performing the first stage of the Swing posture, described in the Kama Sutra. The man cups his partner's face in his hand, as if to seal her mouth, while she holds up a golden wine cup out of his reach.

Though a woman is naturally reserved and keeps her feelings concealed, yet when she gets on top of a man she should show all her love and desire.

(Kama Sutra)

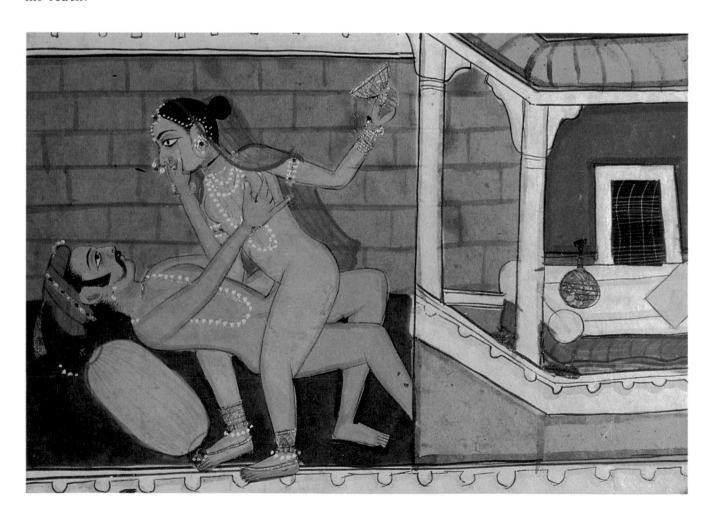

This detail from the same series as the previous example depicts a woman lying back upon a red cusion while her noble lover unites with her in a version of the All-Encompassing position of the Ananga Ranga.

It is the duty of the man to consider the tastes of woman and to be tough or tender, according to his beloved's wishes.

(Koka Shastra)

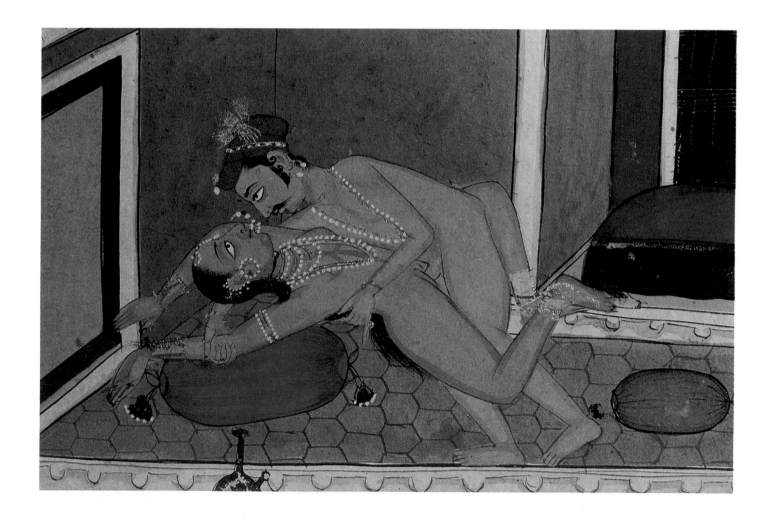

A noble couple make love on a rug surrounded by lotus motifs, with refreshments placed close by. They perform the Variegated posture of the Moon Elixir Tantra, supporting their bodies on a pink cushion. The pastel colors and sensitive treatment of the faces help create a mystic mood.

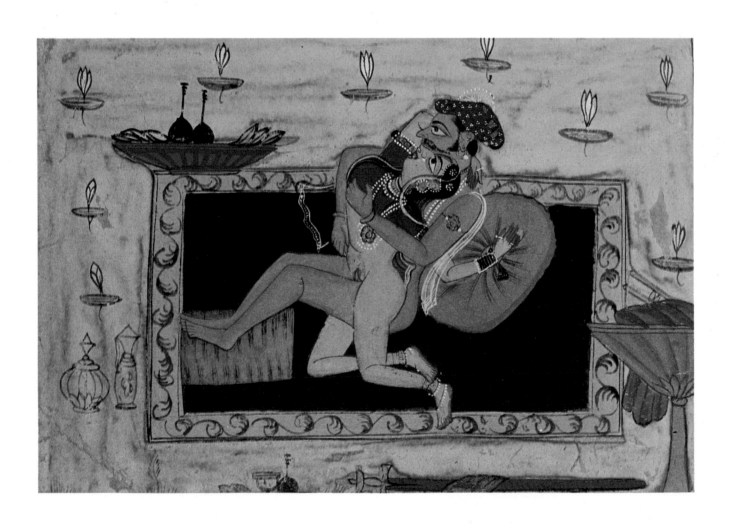

This detail shows a noble couple making love in the unusual Spinning Top posture, described in the Kama Sutra. As the Maharaja reclines, his consort takes up this acrobatic position over him; a maidservant rocks the bed while handing her mistress a cup of wine.

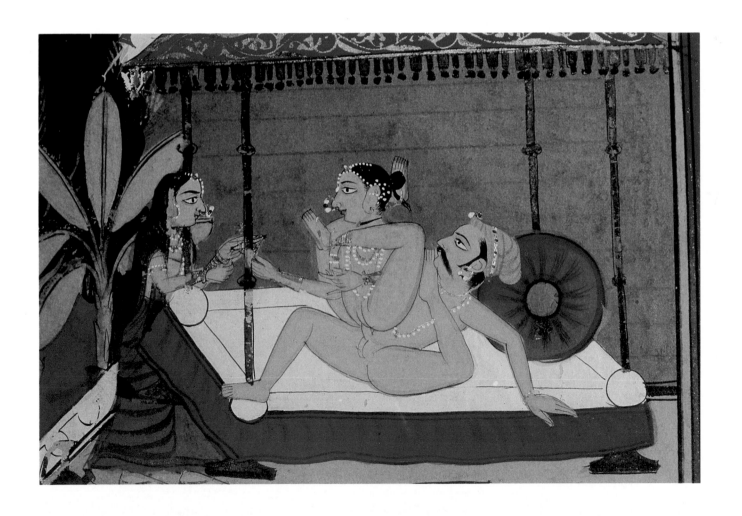

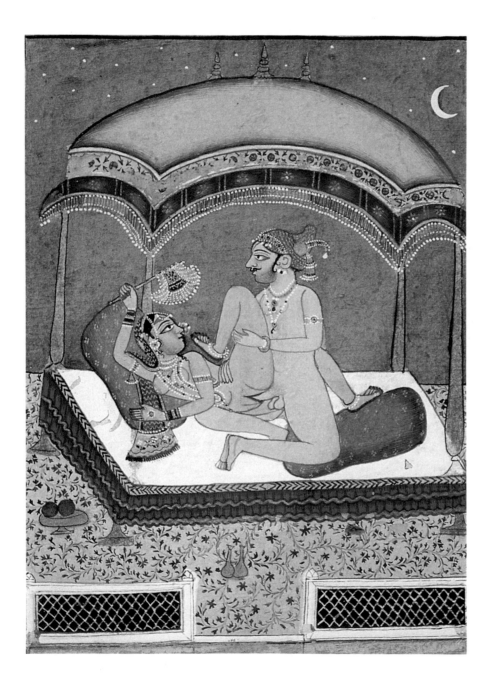

A noble couple are shown making love on an exotic canopied bed located on a palace terrace underneath a crescent moon; stars shine in the lilac sky above. The lovers are performing a variation of the Tantric posture known as Fixing a Nail, described in the Kama Sutra.

A Hindu Maharaja is seated on a palace terrace. His beautiful consort performs oral love as he reclines against a large cushion; flowers burst into bloom in the background. This detail is from a particularly fine Indian painting.

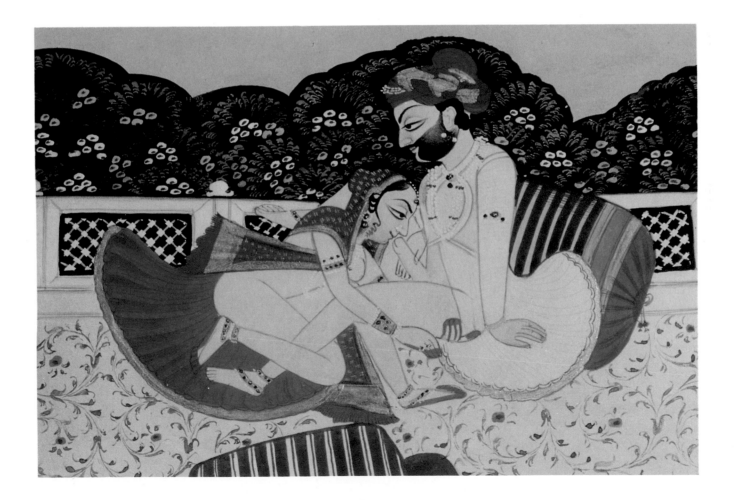

In this detail from a Nepalese painting, a noble couple are depicted in union upon a decorated red carpet. The woman's head rests on a pillow as she raises her legs and performs the Opening and Blossoming position described in the Ananga Ranga. The combination of intense red and pale, cool hues conveys a mood of ardor tempered by calm detachment.

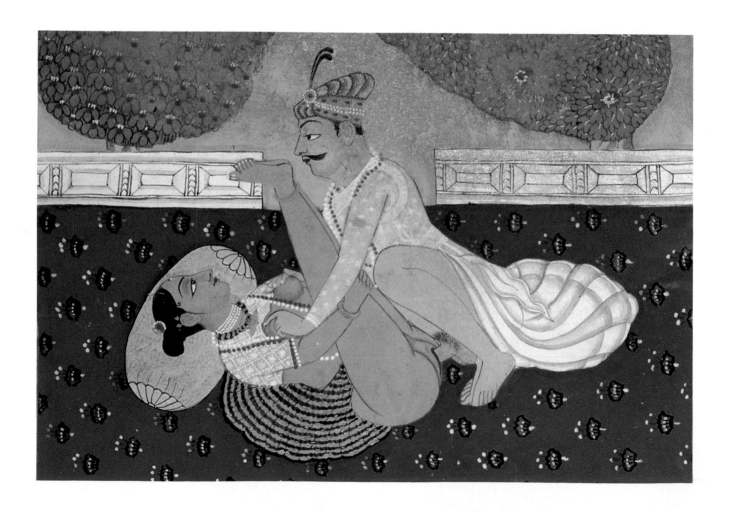

From the same series of Nepalese paintings comes this exquisite detail of a royal couple making love with the woman in the superior role. Together this couple perform the Pair of Tongs posture, described in the Ananga Ranga. The sacred seed-syllable OM can be seen in the background. The mood expressed by this painting is a combination of sensuality and sensitivity.

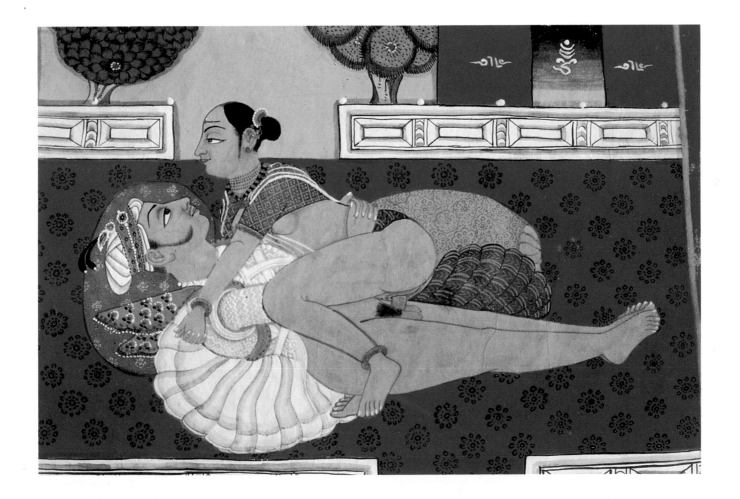

This unusual Nepalese painting depicts a great Mongolian ruler reclining on a temple terrace while his beautiful consort makes love to him in the Tantric posture known as Bee Buzzing over Man, described in the Ananga Ranga. Both wear Mongolian felt boots and exquisite ornaments, and the man rests on fine cushions. To one side the entrance of a temple is embellished with the sacred monogram known as Auspicious Seven, composed of seed-syllables of the vital centers and elements, with a scepter motif and the sacred syllable OM overhead, inscribed in Tibetan characters.

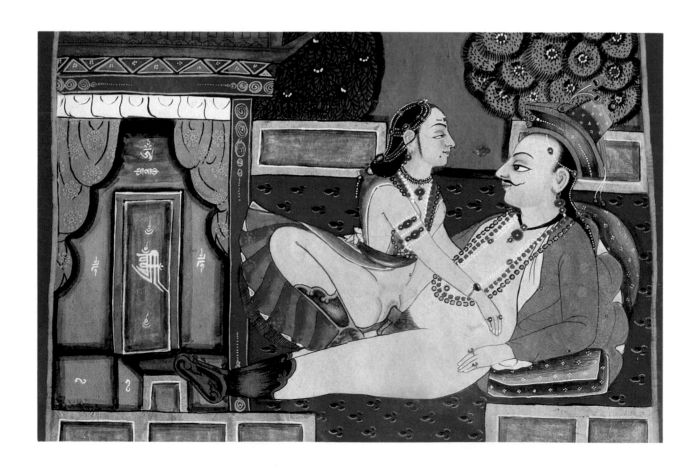

This sensitive Nepalese painting depicts the Persian ruler Muhammad Shah seated in union upon a throne placed upon the terrace of a palace. A beautiful woman perches daintily upon his massive thigh, smiling as she playfully fondles his chin with her hennaed right hand. Despite the Shah's opulence, a sweet sentiment pervades, conveyed through the charming use of color, the flower gardens beyond, and the childlike sensuality of his delightful consort.

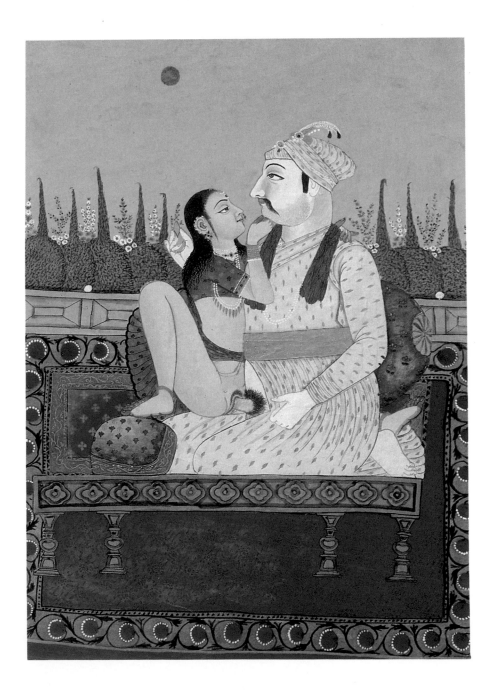

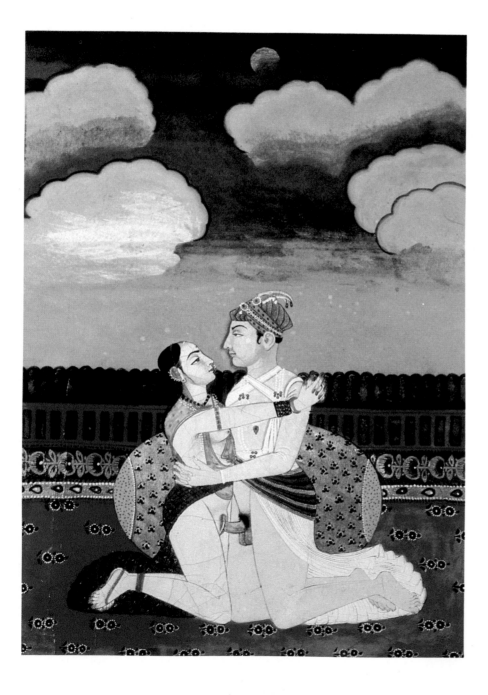

This beautiful Nepalese painting shows a Maharaja and his queen tenderly making love on a carpet placed upon a palace terrace. Both are kneeling, with arms around each other in a variation of the esoteric Pleasure-Evoking posture of the Moon Elixir Tantra. As the couple exchange loving gazes, drinking in each other's spiritual essence, their gentle mood is echoed in the pink cursive clouds floating in the blue sky above. The Maharaja's skin is soft pale pink, and his consort's flesh is like precious ivory.

Day passes into night in this exquisite Nepalese painting of a noble couple standing in erotic union on a palace terrace. The woman holds back her raven tresses as her lover clasps her diaphanous robe in one hand and cups her left breast with the other hand. With her delicate skin and sensuous pose, the royal consort seems like a carved statue coming to life. White birds and pink and blue flowers bedeck the tree branches as the sun sets in a rosy shimmer. The mood is enchanting, evoking the sentiment of sensual love.

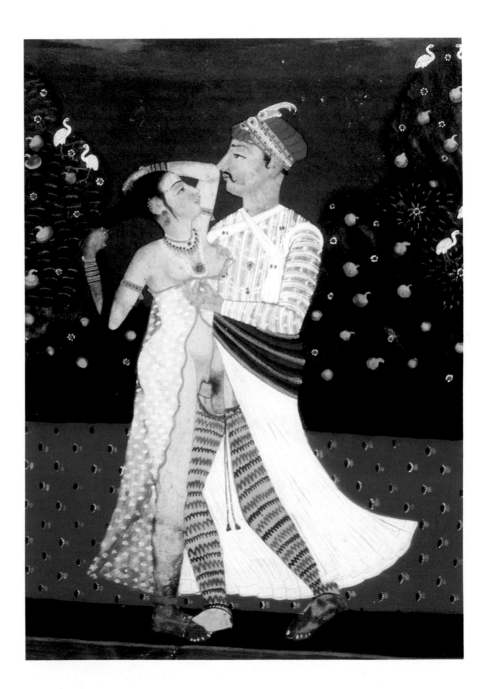

Here a detail from a miniature painting shows a nobleman and his consort in union upon a white bed located within the courtyard of a palace. She crosses her legs and reclines against a cushion, so creating the Lotus-like posture described in the Kama Sutra. The brightly colored geometric shapes of the building contrast excitingly with the bold design of the couple's united bodies.

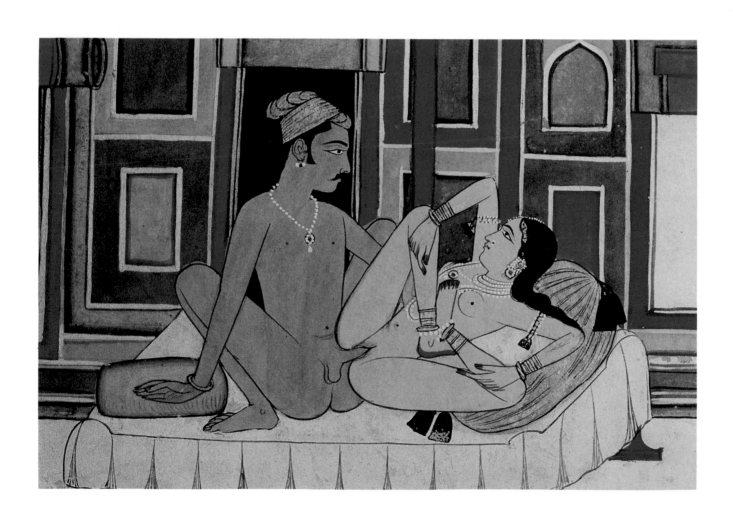

In another detail from the same series as the previous example a nobleman is shown seated in yogic posture upon a bed. His beautiful partner sits on top of his erect Lingam as they perform a version of the Tantric love position known as Splitting a Bamboo, described in the Kama Sutra. Effective use is made of the flat areas of subtle color, creating an intensely dynamic and erotic mood.

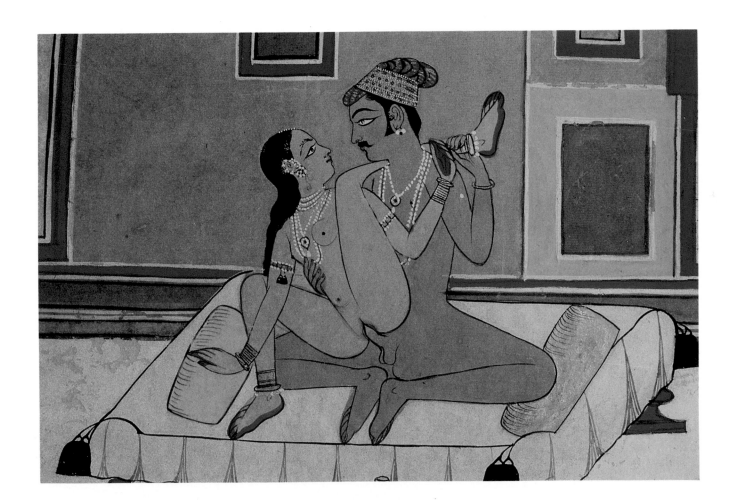

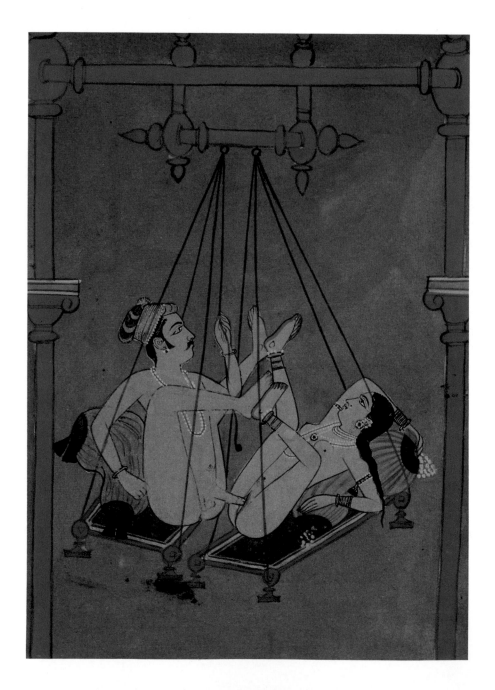

Here a noble couple are captured in the midst of sexual play upon twin swings. They press the soles of their feet together, creating love rhythms as the swings move back and forth. Such ingenious sexual aids were not uncommon in the Orient, serving to heighten erotic fantasy and joyful spontaneity.

This detail from a superb miniature painting depicts a Maharaja in seated union with his beautiful consort. They make love in a version of the All-Around position, described in the **Ananga Ranga.** *As the man supports himself with cushions, his partner clasps him around the neck and looks up at him adoringly. Ritual items and refreshments are scattered in the foreground.*

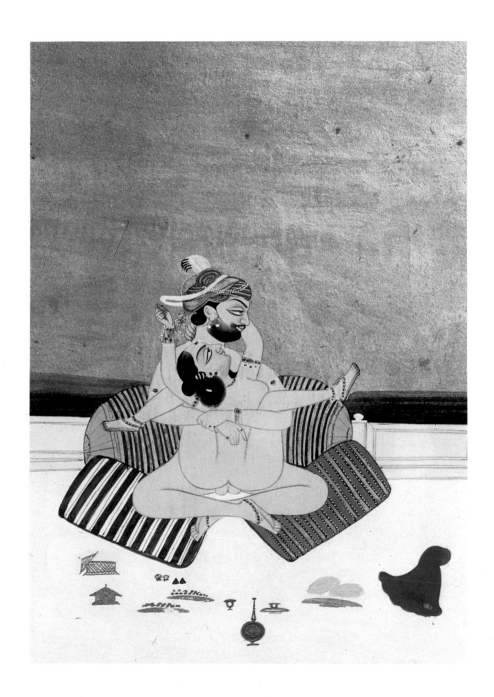

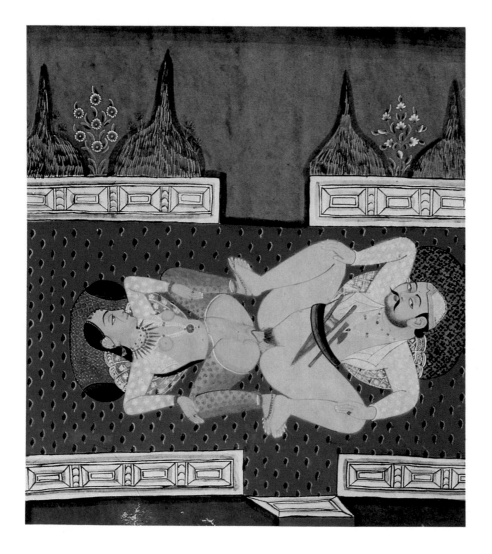

This unusual Nepalese painting shows a noble warrior making love to his consort on the terrace of a palace. They have united their bodies in a Tantric pose; their feet are joined and their hands are placed on their knees to create a closed energy circuit between them. This posture is said to have derived from the lovemaking of butterflies.

An Indian Ruler and his queen are shown making love in a variation of the previous posture. In this case both are holding back their legs with their arms, leaving the Lingam and Yoni as the only point of contact. This is known as a Bandha or "lock," used to control the outward flow of sexual energy. The feet and hands of the woman are red with henna, indicating that she has been prepared for this Tantric practice. The couple gaze upward to the sky, as if recalling their Divine Origin. Ritual items and refreshments are shown in the foreground.

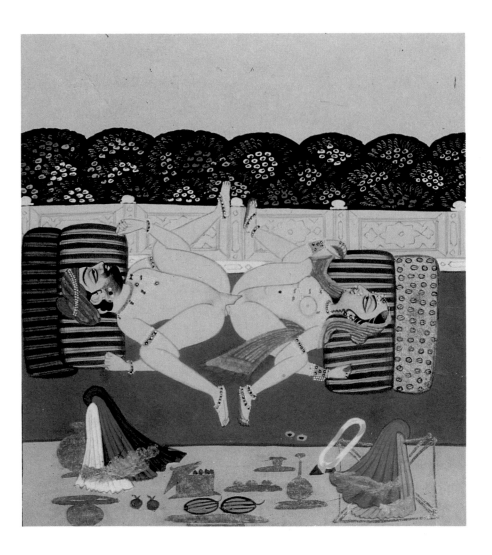

Your being contains mine; now I am truly part of you.
Together as one, we form an unbroken circle of love.
(Kuan Tao)

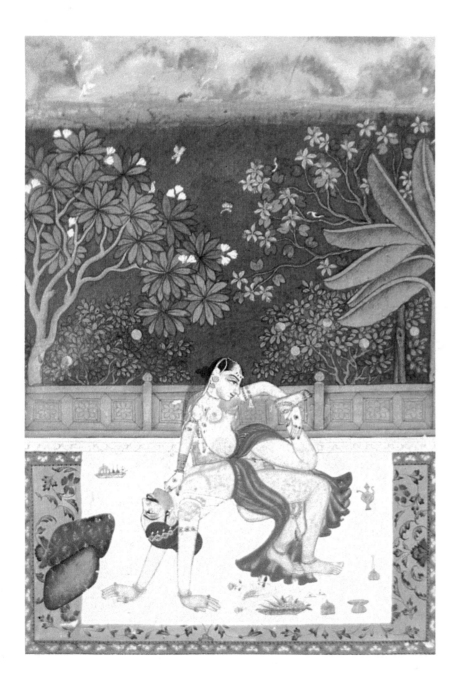

A noble couple acrobatically make love on the terrace of a palace. The man arches his body like a bow and his consort balances on top of him, performing the Spinning Top position, described in the Kama Sutra. Refreshments and ritual items can be seen on the carpet about them, and trees laden with fruit and flowers are visible in the gardens.

Here a noble couple perform another highly complex love posture, supporting themselves on cushions which rest upon an ornate carpet. As they unite in a kind of lover's knot, the man gazes intensely at his consort and artfully fondles her breast with his foot. The composition of this painting conveys a mood of controlled dynamism and balance.

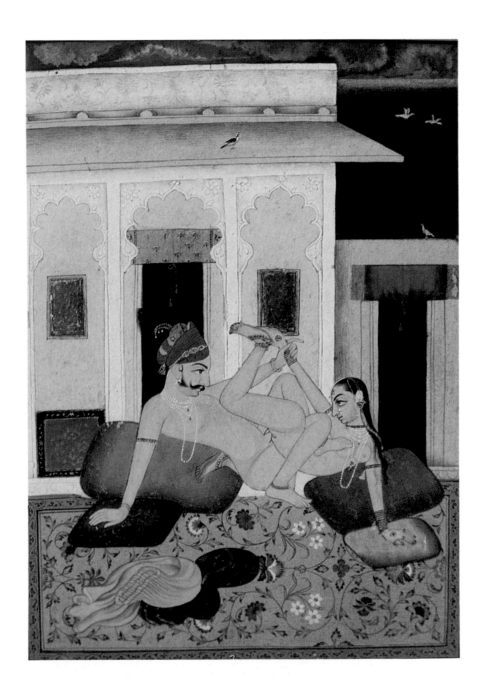

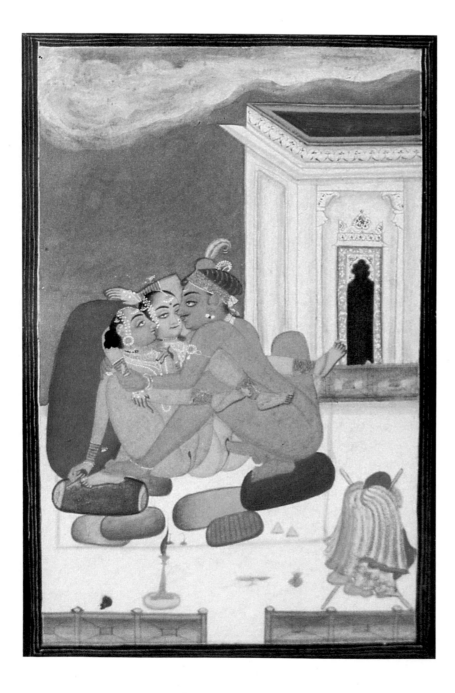

A Maharaja unites with two consorts
on the terrace of a palace. Resting on
brightly colored cushions, the bodies of
the two women conjoin as their lover's
Lingam enters each Yoni in turn.
Together they perform the United
Position, described in the Kama Sutra.
To one side a red flame burns majest-
ically in a lamp, symbolizing the
spiritual quality of this union free from
jealousy.

This detail from an exquisite miniature painting depicts a Maharaja uniting with two consorts supporting themselves on each other as his Lingam enters the Yoni of each in turn. In this unusual version of the United Position, both women turn toward the ruler, their eyes wide in expectancy. Flowers burst into bloom in the background, which is artfully set against silver.

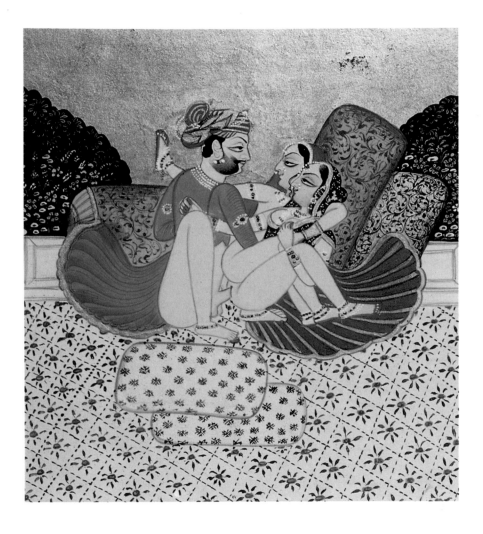

Having made a pillow of each other's arms,
And twining legs with legs,
With minds freed from doubt and shame,
We have not cooled the natural urges
Of our passionate longing.
(Kuttni Mahatmyam)

A Hindu Maharaja unites with his principle consort and two concubines. A sword and shield suggest that this ruler is of the warrior caste. The two lamps over the concubines symbolize that a spiritual rite is being portrayed. This depiction of multiple loving can also be interpreted as the union of the three main subtle nerve-channels of the Tantric tradition.

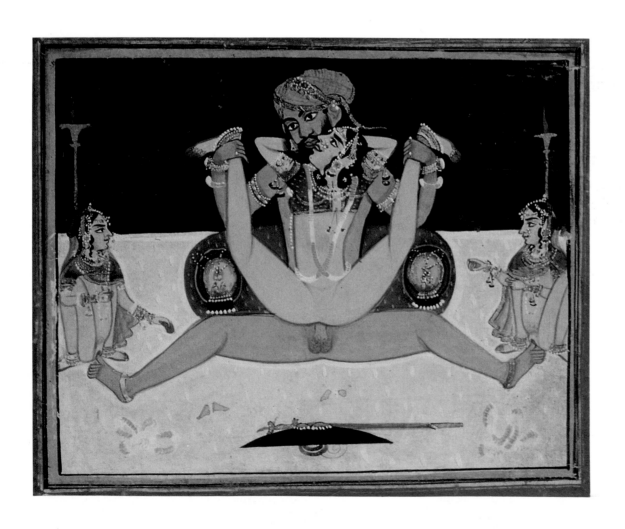

A Maharaja reclines on a couch while engaging in a form of multiple lovemaking referred to in the Kama Sutra as the Herd of Cows. His principle consort takes the active role, squatting over the erect Lingam of her lord, while he stimulates the exposed Yonis of three other ladies. A fifth woman stands in attendance holding flowers.

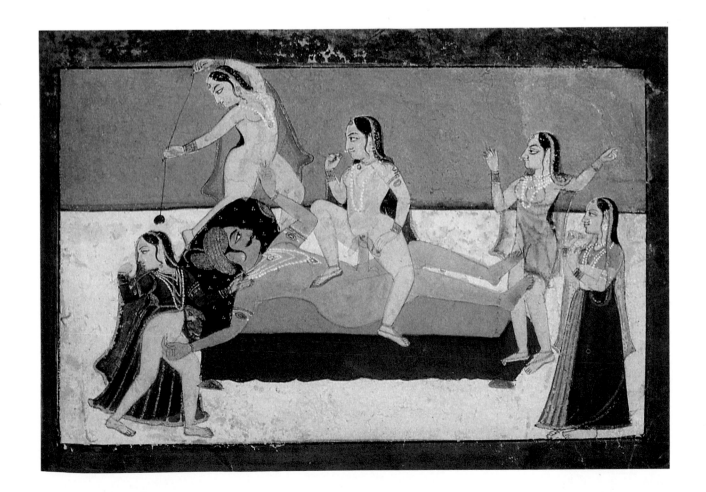

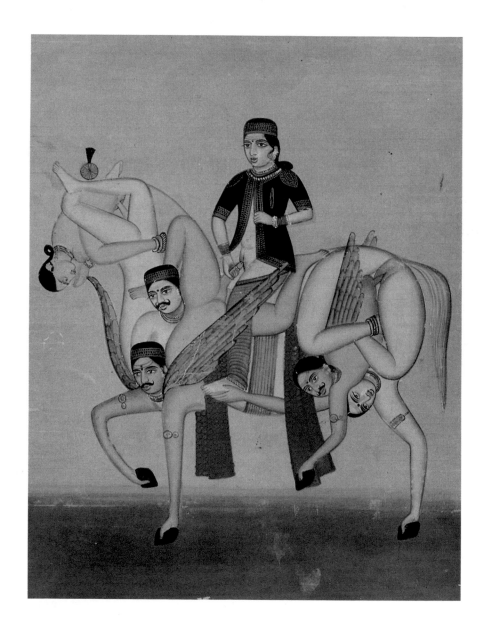

This unusual miniature painting shows a mythological scene, created to attract good fortune through the power of sex. The winged "trick horse" is made up of naked copulating couples artfully entwined. In many Oriental cultures the power of sex is used on a symbolic level, in the belief that it helps attract good luck.

This "trick horse" is composed of a number of couples in union. A Hindu queen is shown in the riding position, a wand of jasmine flowers in her hand. A woman raises her hennaed fingers to create the impression of animal ears. This rare painting must have been created for a Tantric rite of psychic protection.

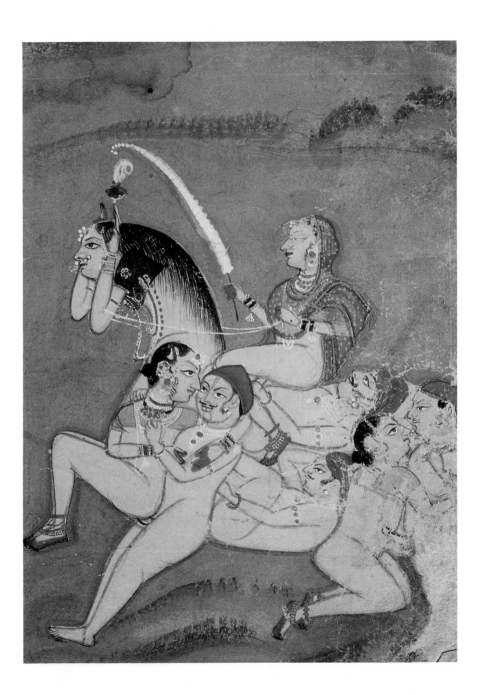

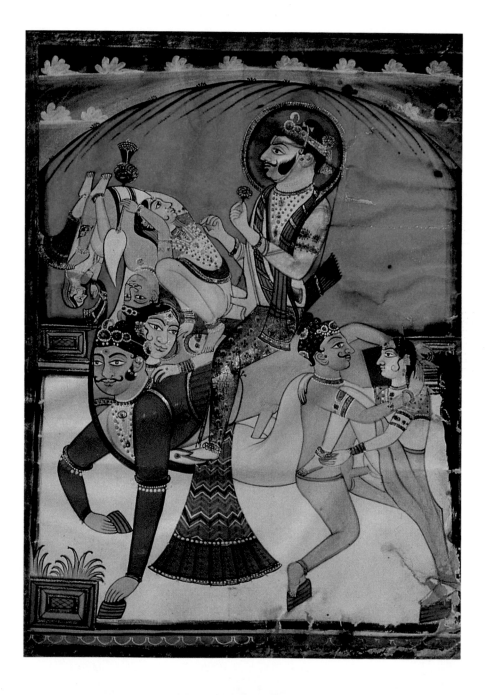

A Hindu Maharaja with a blue and gold halo about his head is shown riding a "trick horse" composed of many naked couples. He holds a rose in his left hand and raises it upward as he rides majestically across the courtyard of a palace. Undoubtedly this fine painting was created as a charm to ensure the prosperity of a ruler.

This extraordinary composition depicts a Maharaja seated in a chariot created by seven naked women. On a symbolic level this scene portrays a ruler in the role of the sun god, who, according to traditional Hindu iconography, rides a chariot pulled by seven horses. The light and dark blue background contrasts with the rich gold and crimson of the Maharaja riding this unusual "chariot," probably composed of women from his harem.

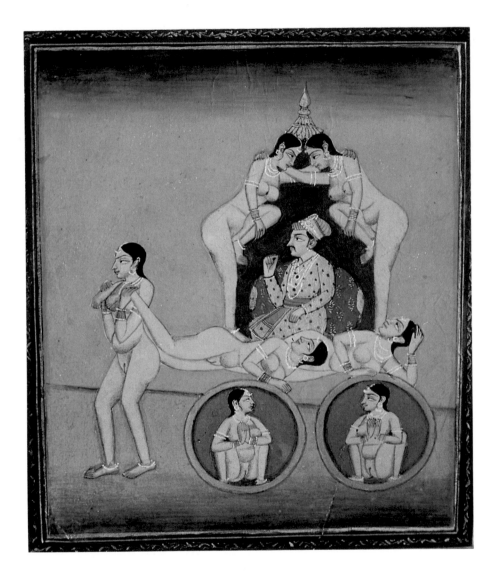

This rare Nepalese painting shows a king in seated union with his beautiful consort. Two fishes, symbolizing the virile power of Vishnu, can be seen under him as he aims a "love arrow" at five women who are paying homage to him; This highly symbolic scene represents the ruler in his role of Kama Deva, the ever-virile god of love.

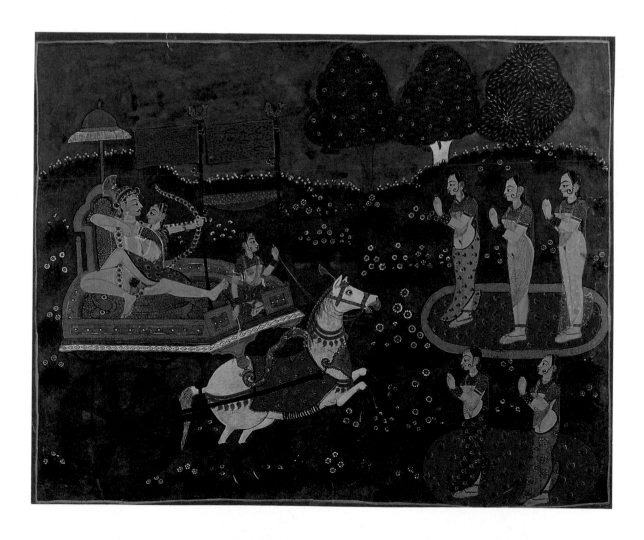

An exquisite detail of a miniature painting shows a Maharaja uniting with five consorts. Each woman plays an instrument, creating a "symphony of love" as their lord harmonizes with each of them simultaneously. Ritual items and refreshments grace the foreground, and lush gardens can be seen in the background. A sweet and lyrical sentiment pervades this scene of erotic harmony.

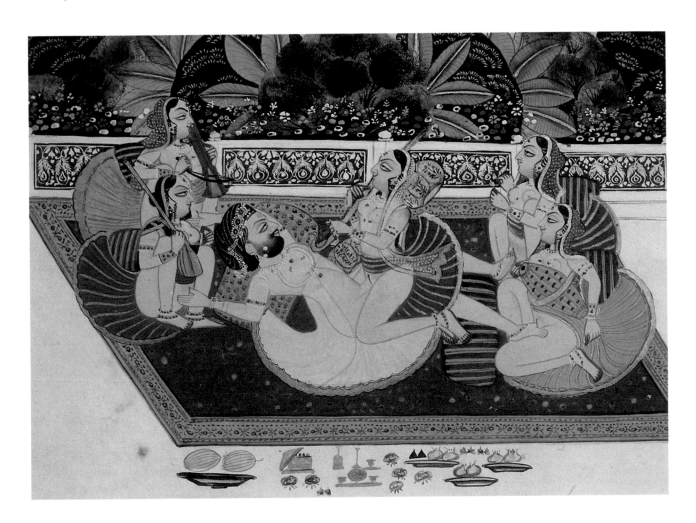

72 Album painting on silk, China, late 19th/early 20th century, size: 12.6 × 15.7 cm.

73 Album painting on silk, China, late 19th/early 20th century, size: 12.8 × 15.8 cm.

74 Album painting on silk, China, late 18th/early 19th century, size: 19.8 × 24.3 cm.

75 Album painting on silk, China, late 18th/early 19th century, size: 20 × 24.5 cm.

76 Album painting on silk, China, late 19th century, size: 16.2 × 20 cm.

77 Scroll painting on silk, China, late 18th/early 19th century, size: 20.1 × 20.9 cm.

81 Gouache on paper, Rajasthan Hills, India, c. 1800, size: 14.7 × 23.3 cm.

82 Watercolor on paper, Bengal, India, early 18th century, size: 18.3 × 26.9 cm.

83 Gouache on paper, Rajasthan Hills Sirohi-style, India, c. 1800, size: 20.6 × 28.1 cm.

84 Watercolor on paper, Bengal, India, early 18th century, size: 19 × 27 cm.

85 Watercolor on paper, Bengal, India, early 18th century, size: 18.5 × 26.9 cm.

86 Watercolor on paper, with gold applied, Deccan Mughal style, India, c. 1700, size: 12.2 × 18.7 cm.

87 Watercolor on paper, with gold applied, Deccan Mughal style, India, c. 1700, size: 12.2 × 18.7 cm.

88 Gouache on heavy paper, Kathmandu Sirohi-style, Nepal, c. 1830, size: 41 × 49.8 cm.

89 Gouache on paper, Rajasthan Hills, India, c. 1800, size: 14.7 × 23.3 cm.

90 Gouache on heavy paper, Kathmandu Sirohi-style, Nepal, c. 1830, size: 40.6 × 49.8 cm.

91 Gouache on heavy paper, Kathmandu Sirohi-style, Nepal, c. 1830, size: 40.9 × 49 cm.

92 Gouache on paper, Jodhpur, India, dated 1830, size: 23 × 31.2 cm.

93 Gouache on paper, Rajasthan Hills Sirohi-style, India, c. 1800, size: 20.4 × 28.1 cm.

94 Gouache on paper, Rajasthan Hills Sirohi-style, India, c. 1800, size: 20.5 × 28.2 cm.

95 Gouache on paper, Rajasthan Hills Sirohi-style, India, c. 1800, size: 16.2 × 23.8 cm.

96 Gouache on paper, Rajasthan Hills Sirohi-style, India, c. 1800, size: 20.5 × 28.2 cm.

97 Gouache on paper, East India Company School, India, c. 1900, size: 9.9 × 12.6 cm.

98 Gouache on paper, East India Company School, India, c. 1880, size: 20.5 × 25.5 cm.

99 Gouache on paper, East India Company School, India, c. 1900, size: 24.5 × 29 cm.

100 Gouache on paper, Rajasthan Rajput, India, c. 1800, size: 25 × 34.4 cm.

101 Gouache on paper, Rajasthan Hills Sirohi-style, India, c. 1800, size: 20.4 × 28.2 cm.

102 Gouache on paper, Rajasthan Bundi-style, India, late 18th century, size: 13.3 × 19.7 cm.

103 Gouache on heavy paper, Kathmandu Sirohi-style, Nepal, c. 1830, size: 40.2 × 50.5 cm.

104 Gouache on paper, Rajasthan Hills, India, c. 1780, size: 14.8 × 17.5 cm.

105 Gouache on paper, Rajasthan Hills, India, mid-18th century, size: 22 × 27.8 cm.

106 Gouache on paper, Rajasthan Hills Sirohi-style, India, c. 1800, size: 20.5 × 28 cm.

107 Gouache on paper, Rajasthan Hills Sirohi-style, India, c. 1800, size: 20.5 × 28 cm.

108 Gouache on paper, Rajasthan, India, c. 1800, size: 20.4 × 25.5 cm.

109 Gouache on heavy paper, Kathmandu Sirohi-style, Nepal, c. 1830, size: 40.6 × 51 cm.

110 Gouache on paper, Rajasthan Hills Sirohi-style, India, c. 1800, size: 20.5 × 28 cm.

111 Gouache on paper, Rajasthan Hills Sirohi-style, India, c. 1800, size: 15.9 × 23.8 cm.

112 Gouache on paper, Rajasthan, India, c. 1880, size: 15 × 22.8 cm.

113 Gouache on paper, Jodhpur, India, dated 1830, size: 22.9 × 31.2 cm.

114 Gouache on paper, Rajasthan Sirohi-style, India, c. 1800, size: 16.5 × 20.7 cm.

115 Watercolor on paper, Bengal, India, early 18th century, size: 18.4 × 26.9 cm.

116 Gouache on heavy paper, Kathmandu Sirohi-style, Nepal, c. 1830, size: 39 × 47.2 cm.

117 Gouache on heavy paper, Kathmandu Sirohi-style, Nepal, c. 1830, size: 38.4 × 48.8 cm.

118 Gouache on heavy paper, Kathmandu Sirohi-style, Nepal, c. 1830, size: 42.7 × 50.5 cm.

119 Gouache on heavy paper, Kathmandu Sirohi-style, Nepal, c. 1830, size: 39.8 × 49 cm.

120 Gouache on heavy paper, Kathmandu Sirohi-style, Nepal, c. 1830, size: 39.4 × 47.8 cm.

121 Gouache on heavy paper, Kathmandu Sirohi-style, Nepal, c. 1830, size: 42.1 × 46.5 cm.

122 Gouache on paper, Bundi school, India, c. 1800, size: 19.6 × 26.8 cm.

123 Gouache on paper, Bundi school, India, c. 1800, size: 20.5 × 26.7 cm.

124 Gouache on paper, Bundi school, India, c. 1800, size: 20.4 × 24.8 cm.

125 Gouache on paper, Jodhpur school, India, dated 1830, size: 23.5 × 32 cm.

126 Gouache on heavy paper, Kathmandu Sirohi-style, Nepal, c. 1830, size: 41.3 × 48.5 cm.

127 Gouache on paper, Jodhpur school, India, dated 1830, size: 24 × 29.2 cm.

128 Gouache on paper, Rajasthan Bundi-style, India late 18th century, size: 19.3 × 12.6 cm.

129 Gouache on paper, Rajasthan Bundi-style, India, late 18th century, size: 13.7 × 20 cm.

130 Gouache on paper, Rajasthan Bundi-style, India, c. 1800, size: 13.2 × 21 cm.

131 Gouache on paper, Jodhpur school, India, dated 1830, size: 23 × 31.4 cm.

132 Gouache on paper, Rajasthan, India, late 18th century, size: 12.9 × 15.4 cm.

133 Gouache on paper, Basohli school, India, early 18th century, size: 10.2 × 14.8 cm.

134 Gouache on paper, Lucknow school, India, c. 1900, size: 21.2 × 28.1 cm.

135 Gouache on paper, Jodhpur school, India, c. 1780, size: 12.6 × 19.7 cm.

136 Gouache on paper, Jaipur Rajasthan school, India, c. 1800, size: 18 × 24.4 cm.

137 Gouache on paper, Rajasthan, India, early 19th century, size: 24.6 × 31 cm.

138 Gouache on heavy paper, Kathmandu Sirohi-style, Nepal, c. 1830, size: 39 × 49 cm.

139 Gouache on paper, Jodhpur school, India, dated 1830, size: 29 × 34.2 cm.

BIBLIOGRAPHY

Anand, Mulk Raj. *Kama Kala.* Geneva: Nagel, 1963.

Beurdeley, Michel, et al. *The Clouds and the Rain.* London: Hammond and Hammond, 1969.

Bowie, Theodore, and Cornelia V. Christenson. *Studies in Erotic Art.* New York: Basic Books, 1970.

Chang, Jolan. *The Tao of Love and Sex.* London: Wildwood House, 1977.

Douglas, Nik. *The Art of Love.* Beverly Hills: Kreitman Gallery, 1979.

———, and Penny Slinger. *Sexual Secrets: The Alchemy of Ecstasy.* New York: Destiny Books, 1979.

Etiemble. *Yun Yu: An Essay on Eroticism and Love in China.* Geneva: Nagel, 1970.

Evans, Tom, and Mary Evans. *Shunga: The Art of Love in Japan.* New York: Paddington Press, 1975.

Franzblau, Abraham N. *Erotic Art of China.* New York: Crown, 1977.

Gerhard, Poul. *Pornography or Art?* Bishop's Stortford, England: Words and Pictures, 1971.

Grosbois, Charles. *Shunga: Images of Spring.* Geneva: Nagel, 1965.

Grove Press editors. *Fille de Joie.* New York: Grove Press, 1967.

Illing, Richard. *Japanese Erotic Art.* New York: St. Martins Press, 1979.

Kronhausen, Phyllis, and Eberhard Kronhausen. *The Complete Book of Erotic Art.* New York: Bell, 1978.

———. *Catalogue of the International Museum of Erotic Art.* San Francisco: National Sex Forum, 1973.

Kuhn, Franz. *The Before Midnight Scholar (Jou Pu Tuan of Li Yu).* London: Deutsch, 1965.

Mandel, G., and F.M. Ricci. *Tantra: Rites of Love.* New York: Rizzoli, 1979.

Mookerjee, Ajit. *Tantra Art.* Basel: Kumar, 1971.

———. *Tantra Asana.* Basel: Kumar, 1971.

Neuer, Roni, and Stephanie Kiceluk. *Shunga: The Erotic Art of Japan (1600-1979).* New York: Ronin Gallery, 1979.

Rawson, Philip. *Erotic Art of the East.* New York: Prometheus, 1968.

———. *Tantra: Catalogue of an Exhibition at the Haywood Gallery.* London: Arts Council, 1971.

———. *Tantra: The Indian Cult of Ecstasy.* London: Thames and Hudson, 1973.

———. *Erotic Art of India.* London: Thames and Hudson, 1977.

Smith, Bradley. *Erotic Art of the Masters.* La Jolla, Calif.: Gemini-Smith, no date.

Thomas, P. *Kama Kalpa: The Hindu Ritual of Love.* Bombay: Taraporevala, 1959.

Tucci, Giuseppe. *Rati Lila: An Interpretation of the Tantric Imagery of the Temples of Nepal.* Geneva: Nagel, 1969.

Van Gulik, Robert H. *Erotic Color Prints of the Ming Period.* Privately published, Tokyo, 1951.

———. *Sexual Life in Ancient China.* Leiden: Brill, 1974.

Los Niños y la Ciencia

DISEÑOS DE LAS PLANTAS

Aaron Carr

www.av2books.com

This AV² media enhanced book gives you a fully bilingual experience between English and Spanish to learn the vocabulary of both languages.

English

Spanish

AV² Bilingual Navigation

CHANGE LANGUAGE ENGLISH SPANISH — **LANGUAGE TOGGLE**

BACK NEXT — **PAGE TURNING**

X CLOSE

⌂ HOME

PAGE PREVIEW

DISEÑOS DE LAS PLANTAS

CONTENIDO

¿Qué diseño ves?

4

Una hoja tiene un diseño de líneas.

¿Qué diseño tiene la madera?

¿Qué diseño ves?

La madera tiene un diseño de líneas redondas.

¿Qué diseño tienen las flores?

7

¿Qué diseño ves?

Las flores tienen un diseño de colores.

¿Qué diseño tienen los tulipanes?

9

¿Qué diseño ves?

Estos tulipanes
tienen un diseño
de colores rojo y
amarillo.

¿Qué diseño
tiene la hoja?

¿Qué diseño ves?

Algunas hojas tienen un diseño de triángulos a lo largo de sus bordes.

¿Qué diseño forman estas hojas de plantas?

¿Qué diseño ves?

Algunas hojas de las plantas forman un diseño en espiral.

¿Qué diseño tiene el brócoli?

15

¿Qué diseño ves?

Este brócoli tiene un diseño de protuberancias.

¿Qué diseño tiene un girasol?

¿Qué diseño ves?

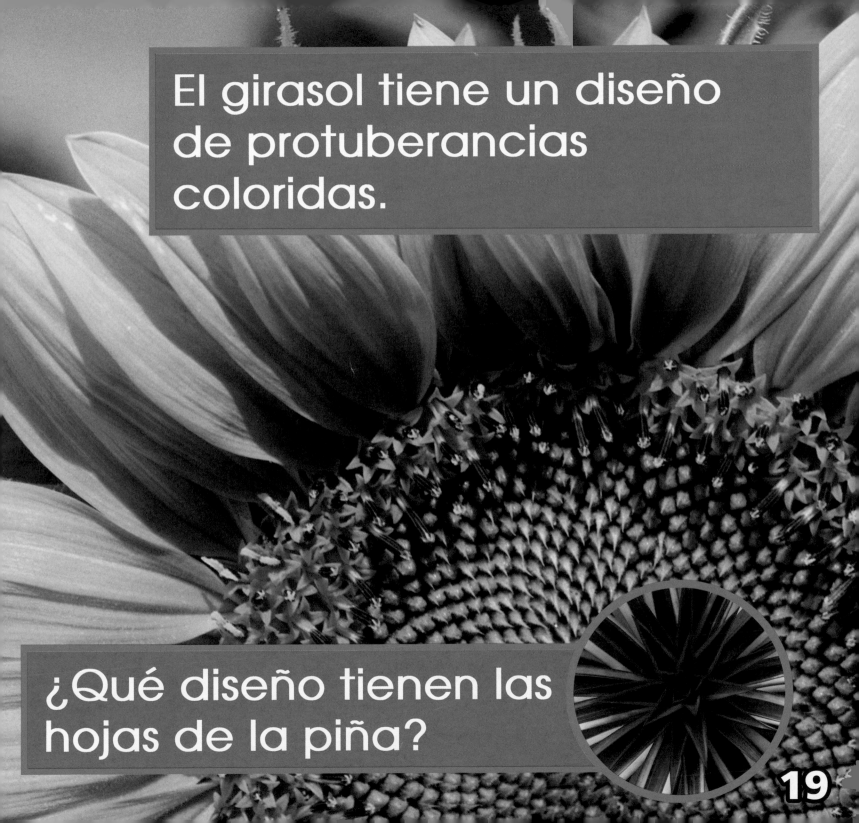

El girasol tiene un diseño de protuberancias coloridas.

¿Qué diseño tienen las hojas de la piña?

19

¿Qué diseño ves?

Las hojas de la piña tienen diseños de líneas, colores y triángulos.

¿PUEDES ENCONTRAR ESTOS DISEÑOS?

Líneas Colores Triángulos Protuberancias

22

23

Check out av2books.com for your interactive English and Spanish ebook

1 Go to av2books.com

2 Enter book code A325742

3 Fuel your imagination online!

www.av2books.com

Published by AV² by Weigl
350 5th Avenue, 59th Floor New York, NY 10118
Website: www.av2books.com www.weigl.com

Library of Congress Cataloging-in-Publication Data

Carr, Aaron.
 [Plant patterns. Spanish]
 Diseños de las plantas / Aaron Carr.
 p. cm. -- (Los niños y la ciencia)
 Includes bibliographical references and index.
 ISBN 978-1-61913-207-8 (hardcover : alk. paper)
 1. Pattern perception--Juvenile literature. 2. Color in nature--Juvenile literature. I. Title.
 BF294.C3718 2012
 152.14'23--dc23
 2012021232

Printed in the United States of America in North Mankato, Minnesota
1 2 3 4 5 6 7 8 9 0 16 15 14 13 12

062012
WEP100612

Senior Editor: Heather Kissock
Art Director: Terry Paulhus

Weigl acknowledges Getty Images as the primary image supplier for this title.